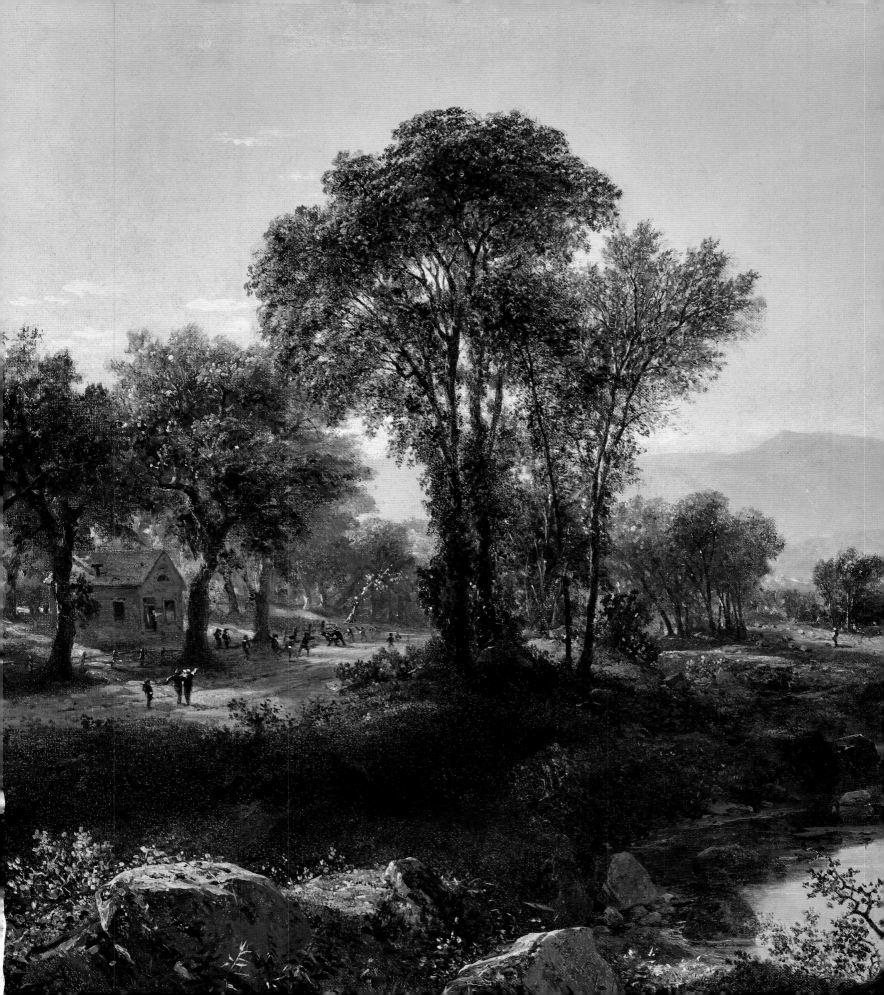

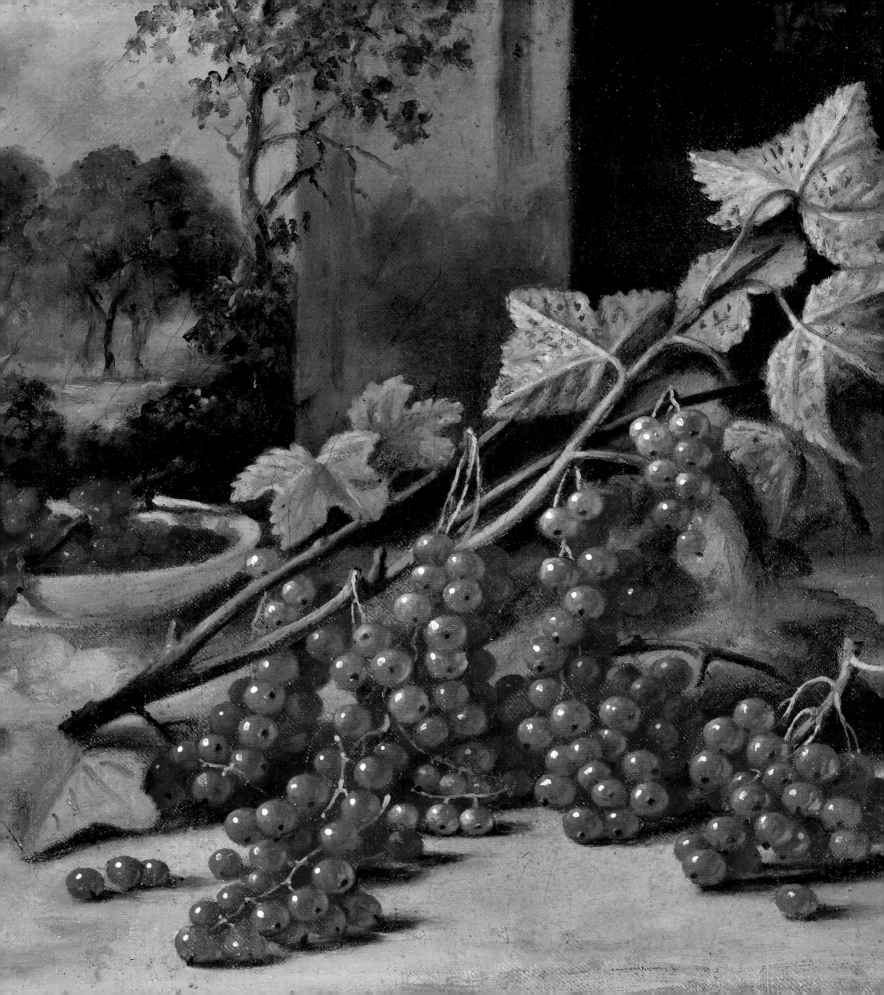

American Beauty and Bounty

The Judith G. and Steaven K. Jones
Collection of Nineteenth-Century Painting

BRUCE ROBERTSON AND SCOTT A. SHIELDS

With contributions from

Virginia Reynolds Badgett • Sarah Bane

Sophia Gimenez • Mary Okin • Lilit Sadoyan

Sacramento, California

Published on the occasion of the exhibition

American Beauty and Bounty

The Judith G. and Steaven K. Jones
Collection of Nineteenth-Century Painting

Crocker Art Museum
October 28, 2018–January 27, 2019

CROCKER
art museum

Crocker Art Museum
216 O Street
Sacramento, CA 95814
www.crockerart.org

LIBRARY OF CONGRESS CONTROL NUMBER: 2018953630

ISBN 978-1-938901-81-2

PAGE I: John Frederick Kensett, *School's Out*, 1850, detail (cat. no. 20).
FRONTISPIECE: John Francis, *Still Life with Currants*, circa 1870, detail (cat. no. 12).
FACING: Asher B. Durand, *Pastoral Landscape*, 1866, detail (cat. no. 10).
PAGE VI: William Bradford, *Coast of Labrador*, 1866, detail (cat. no. 3).
PAGES 56-57: William M. Hart, *Coast of Maine*, 1868, detail (cat. no. 15).

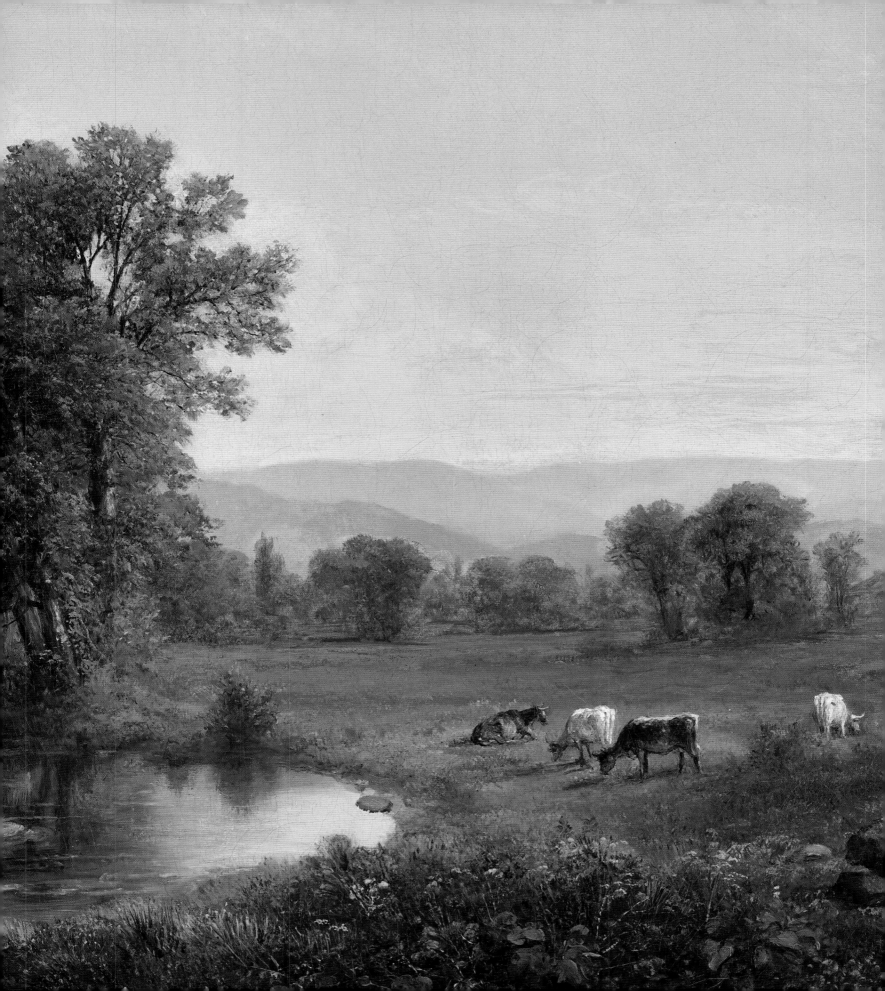

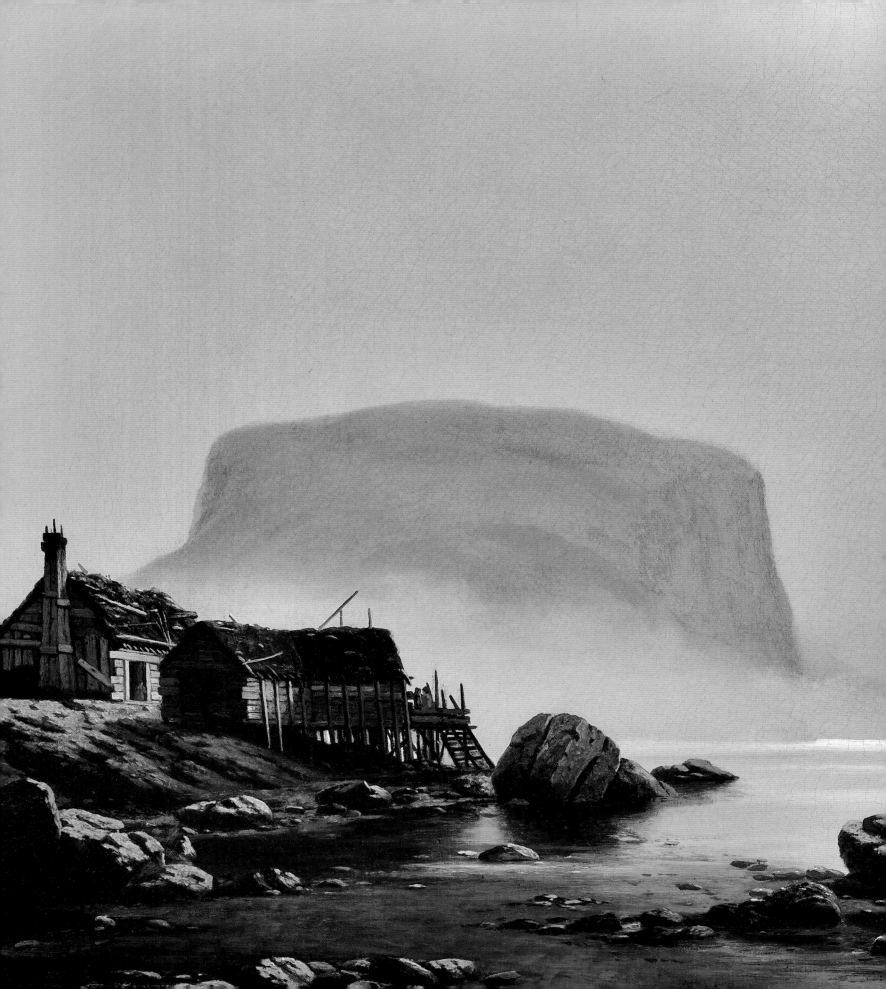

CONTENTS

FOREWORD

The Crocker Art Museum is known for its signature collection of California art, much of which is currently displayed in its Gwathmey Siegel and Associates building (opened to the public in 2010). A collecting area less familiar, however, lies within this chronologically installed collection: works by American artists from outside California. These paintings, sculptures, photographs, and decorative arts provide context for the achievements of the Californians but also form a broader narrative of American art as a whole. As this American collection continues to grow, the Crocker will be increasingly able to offer visitors a uniquely well-rounded art experience—one that includes works of important artists from both the west and east coasts, as well as regions in between.

Since the gold rush, artists calling California home have been well versed in national and international aesthetic trends. Historically, too, a vast number of these artists have been not natives but transplants from other parts of the country or world. Many also perfected their craft by training in other locations, meaning that their worldviews were far from provincial. Judge E. B. Crocker, along with his wife, Margaret, and their children, recognized the achievements of California artists early on. Having made an extended art-buying trip abroad from 1869 to 1872, the family returned to Sacramento with some 700 European paintings and 1,300 master drawings. They installed many of these pieces in their newly constructed gallery building.

Before this excursion, the Crockers possessed only a few California paintings, along with several "Rogers Groups" by the popular sculptor of the American East, John Rogers, whose sculptural vignettes of daily life graced parlors across the country. Upon their return from abroad, the Crockers became committed to collecting the work of contemporary California artists, acquiring numerous iconic examples still held by the Museum.

Following E. B. Crocker's death in 1875, the family's collection essentially stopped growing,

and little was added to these original holdings until the mid-twentieth century. At that time, not only were works of art by new and more recent Californians added to the collection, but so, too, were paintings by American artists generally, among them compositions by George de Forest Brush, Marsden Hartley, Childe Hassam, Robert Henri, Rockwell Kent, Georgia O'Keeffe, and Moses Soyer. Through donations and funded purchases, this American collection has since continued to grow, with paintings by Theodore Butler, Eanger Irving Couse, Frederick Frieseke, Richard Miller, and Elihu Vedder integrated in more recent years, and with works by John Twachtman and Frederick William MacMonnies promised as bequests.

The Crocker has also recently added examples by American modernists of the Midwest and Southwest, including paintings by the Kansan Birger Sandzén, as well as works by the New Mexico transcendentalists Raymond Jonson and Emil Bisttram. More contemporary American additions include sculptures by Elizabeth Catlett, Allan Houser, and Luis Jiménez, along with paintings by Richard Anuszkiewicz, Al Held, Paul Jenkins, and Jaune Quick-to-See Smith. The Crocker's collections of photography and craft media are also national in scope.

Joining these holdings one day will be the paintings featured in this catalogue and the exhibition it accompanies: the Judith G. and Steaven K. Jones Collection. This collection constitutes the most important gift of American art from beyond California's borders ever to come to the Crocker. Paintings in the collection exemplify an era when American collectors most appreciated the work of American artists. The same has more recently been true of the Joneses, who selected each piece with care, for both its beauty and its importance, and for what it could contribute to the overall collection. Included are paintings by America's premier landscapists—Ralph Blakelock, William Bradford, Jasper Cropsey, Thomas Doughty, Asher B. Durand, Sanford Robinson Gifford, John Frederick Kensett, William Trost Richards, and Thomas Worthington Whittredge—some of whom are represented by more than one work. The collection also offers still lifes by George Forster, John Francis, William Harnett, Claude Raguet Hirst, and Severin Roesen, as well as genre paintings by Thomas Hicks, Eastman Johnson, Jervis McEntee, and Enoch Wood Perry, Jr. Most recently, after deciding that the Crocker would be the ultimate home for these paintings, the Joneses added a work by Albert Bierstadt, who came to California from the East for two extended stays. The painting depicts the artist and his wife and sister-in-law picnicking near Oakland, the picture providing a thematic link between the Joneses' East Coast paintings and the Crocker's California views. Along with these artworks, the Jones Collection will be accompanied by an endowment for the collection's care and strategic growth, for which the board and staff of the Museum are extremely grateful.

For his pivotal role in enabling this gift and publication to happen, the Museum is indebted to Bruce Robertson of the University of California, Santa Barbara, who graciously brought the Joneses and the Crocker together and helped to write and edit the catalogue. We also wish to thank Bruce's talented students Virginia Reynolds Badgett, Sarah Bane, Sophia Gimenez,

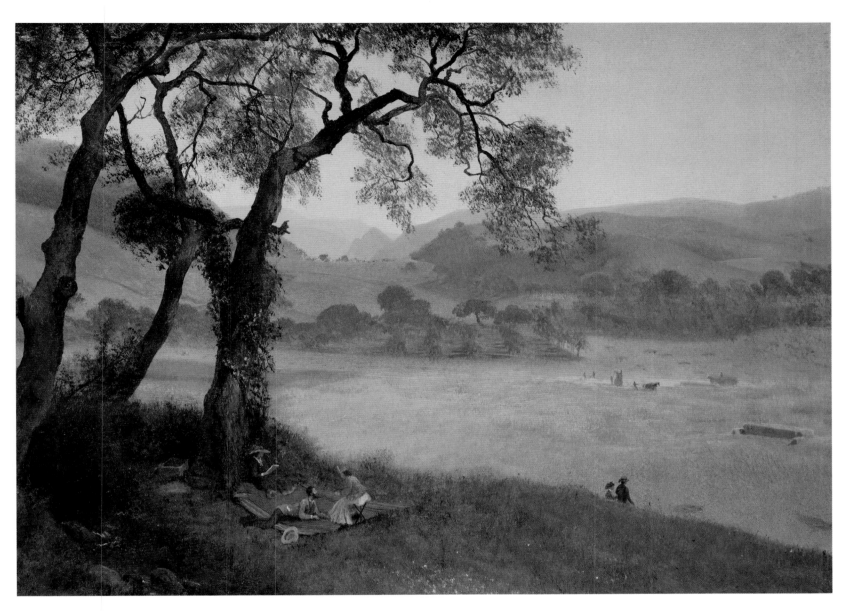

Albert Bierstadt, *A Golden Summer Day Near Oakland*, circa 1873 (cat. no. 1).

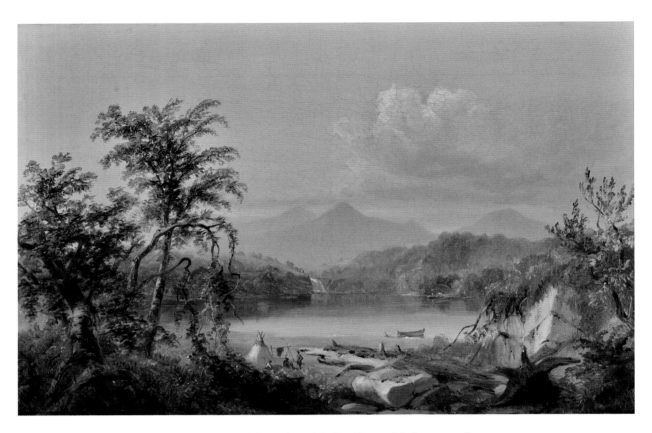

Russell Smith, *Silver Lake with Indian Teepee*, 1867 (cat. no. 26).

Mary Okin, and Lilit Sadoyan, who researched the paintings included in this book and contributed catalogue entries. For creating such a beautiful publication, we thank LeRoy Wilsted and Christine Taylor of Wilsted and Taylor Publishing Services, whose team includes editor Melody Lacina and designer Nancy Koerner. We are also grateful to Gerard Vuilleumier for so beautifully photographing the artworks included in this book. We thank the Crocker Art Museum's co-trustees and staff, most especially Mariah Briel, John Caswell, Ashleigh Crocker, Christie Hajela, Matthew Isble, and Kristina Perea Gilmore, who were particularly instrumental in bringing the exhibition and catalogue to fruition.

Most significantly, for their extraordinary generosity and for the trust they have placed in the Museum, we thank Judith G. and Steaven K. Jones and their family. We know that their paintings will be much beloved in the Sacramento region and beyond, and that these fine works will add immeasurably to visitors' experiences for generations to come. We also know that this gift will be transformative on national and international levels, elevating the stature of the Crocker Art Museum and forever changing its commitment to the broad and beautiful diversity of art created across the United States.

Lial A. Jones
Mort and Marcy Friedman Director and CEO

Scott A. Shields, Ph.D.
Associate Director and Chief Curator

American Beauty and Bounty

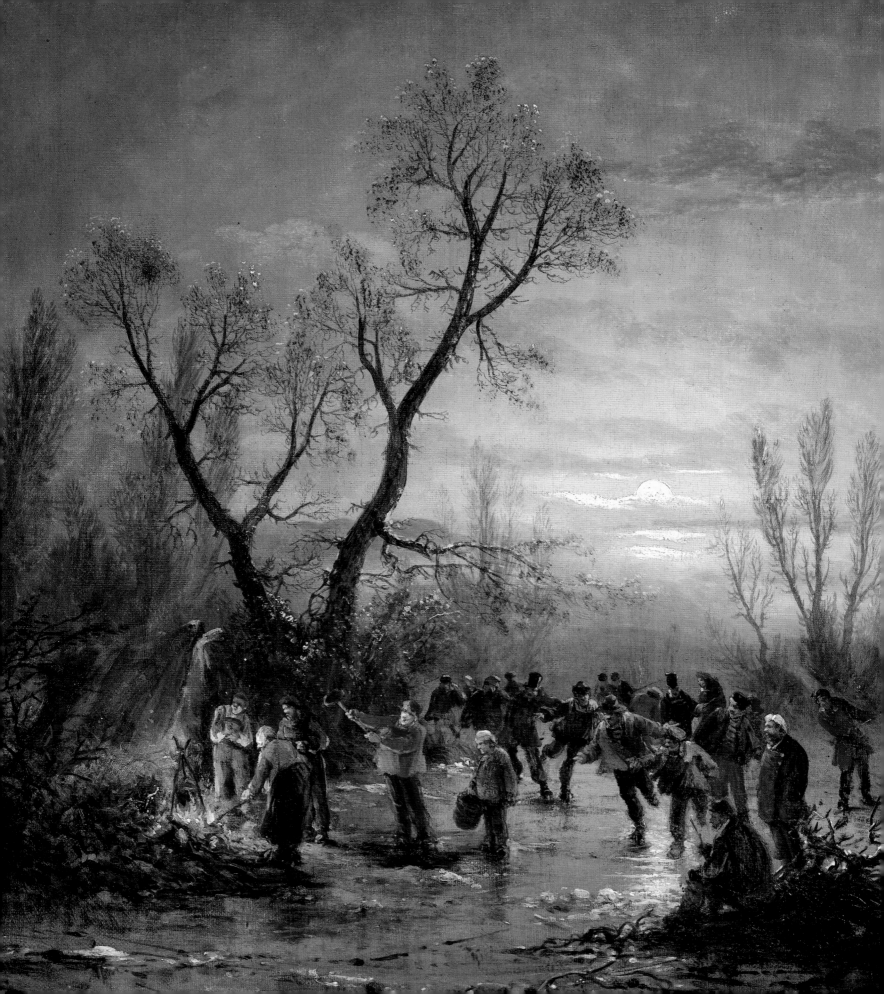

COLLECTORS' STATEMENT

Judith G. and Steaven K. Jones

THE COLLECTING BUG bit us about twenty years into our marriage, when we inherited some furniture and Oriental rugs from family. Steaven's stepmother was a serious collector of eighteenth- and early nineteenth-century American furniture, and Judy's uncle collected Baluchi rugs and was president of the Ali Baba Society in Washington, D.C. We then had beautiful things in the center of rooms and on the floors—but nothing on the walls. And we had not developed a plan to rectify that situation. However, when we visited museums, and when Judy gave docent tours at the Los Angeles County Museum of Art (LACMA), our concentration was always on historic art in the American galleries. Plus, we both had been educated in the Boston area, steeped in American history, decorative arts, and culture. So it was natural, on our next visit to New York, that we would seek out and visit the top galleries featuring American art. Chief among them was the Kennedy Galleries, headed by the persuasive and gregarious Larry Fleischman, who probably took one look, saw our inexperience and lack of confidence, and knew he had an easy sales task ahead. We did, in fact, see several pieces we immediately loved, but we focused on a portrait by William Merritt Chase of his daughter, Helen Velasquez Chase. The price tag was intimidating, but we rationalized that it was "Art" and bought the painting without negotiating (which Steaven has forever regretted). Ironically, though we purchased several other paintings from the Kennedy Galleries, the Chase was one of the very few that we decided to give up when we realized that we wanted to focus on earlier works.

Having made our first purchase—and quickly feeling the urge for more—we knew we needed to become more knowledgeable about the market. We subscribed to Christie's and Sotheby's biannual American catalogues and pored over them. We increased our number of visits to New York and went to every gallery that featured American art. We became more active in the American art council at LACMA, attended the

FACING: Enoch Wood Perry, Jr., *Ice Skating Party*, circa 1870, detail (cat. no. 22).

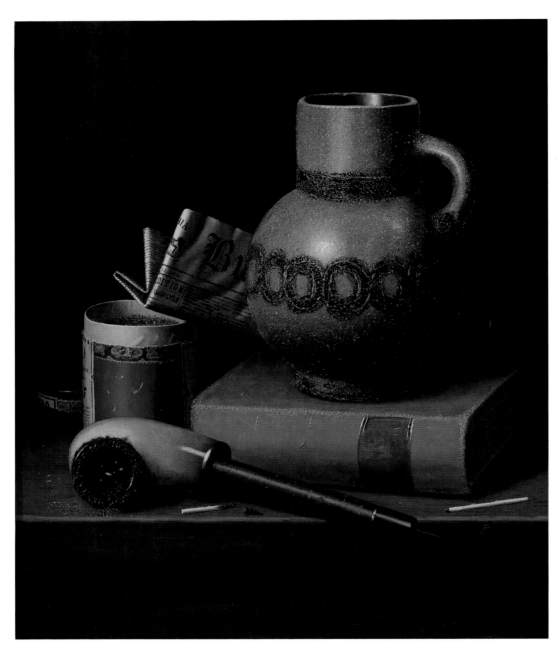

William Harnett, *Still Life with Book, Pitcher, Pipe, Tobacco and Matches with a Newspaper*, 1878 (cat. no. 14).

meetings, visited homes of collectors, and went on their sponsored trips to other cities. Michael Quick, who was then curator of American art, was extremely supportive, providing advice on galleries to visit and even specific paintings to consider. When we made a purchase, he was kind enough to examine the painting for condition and quality and "vet" the work.

As the years went by, we became more confident in our choices. We set a time frame—1803 to 1875—that we have adhered to with only one exception, a still life by Claude Raguet Hirst (cat. no. 17), because of her connection to William Harnett (their studios were contiguous) and because she was a woman who was successful in a man's world. We loved the landscapes and relished the thought that, before widespread photography, they recorded an America on the cusp of change, just before the industrial revolution. Two of our landscape paintings were created in 1864; they are amazingly peaceful and bucolic, when you consider what was happening that year in our country. The genre scenes are also typical of America at that time, now gone forever: Jervis McEntee's interior of a woman, in black, seated before a fire with a picture of a Civil War soldier (her husband?) on the wall (cat. no. 21); Eastman Johnson's study of two boys in his *At the Maple Sugar Camp* (cat. no. 19); Thomas Hicks's rustic kitchen interior (cat. no. 16); and Enoch Wood Perry's night ice-skating scene (cat. no. 22).

The still lifes were later additions but are among our most cherished. The Harnett in the entry hall (cat. no. 14) is a special favorite. The others live in the dining room, where we can enjoy the fruits and vegetables both on our plates and on the walls.

Judith G. and Steaven K. Jones in their home featuring paintings by William Bradford and John Wesley Jarvis from their collection.

Why did we decide to bequeath the paintings to the Crocker Art Museum? We always knew we wanted them to go to an institution, if possible, not to be sold and dispersed. Bruce Robertson, former curator of American art at LACMA and esteemed professor of American art at the University of California, Santa Barbara, suggested the Crocker to us. As he said, it is the oldest museum west of the Mississippi, is located in our state capital, and, consequently, has a steady stream of visitors. It has a wonderful collection of European and California art—but very little from nineteenth-century East Coast artists. Our paintings, he thought, would be a nice introduction to the American galleries. We met with Scott A. Shields, associate director and chief curator at the Crocker, toured the museum, and agreed. This is the right place for our collection. We are delighted beyond words that the Crocker Art Museum is where our carefully selected, long-enjoyed paintings will reside.

COLLECTING THE EAST IN THE WEST

Building Collections of Hudson River School Painting in California

Bruce Robertson

JUST AS AMERICAN ART, like the nation itself, is relatively young, the collecting of art by American artists is a new phenomenon as well. While in Europe art collections have been assembled since the early sixteenth century, long before public museums existed, in this country private and public collecting have evolved hand in hand. Thus the gift of the collection built by Judith and Steaven Jones to the Crocker Art Museum fits within a tradition of collaboration and mutual assistance: most American museums have benefited significantly from the generosity of individuals.

American museums and private collectors have acquired nineteenth-century American paintings from the moment collections of American art began to be assembled, around the mid-nineteenth century. But these were all collections of contemporary art, often bought from the artists themselves. The Crocker is a perfect example: in addition to the old master paintings and drawings they purchased, Edwin Bryant and Margaret Crocker bought the art being produced around them—quite literally in the case of such California painters as Thomas Hill, William Keith, and Charles Christian Nahl. The Crockers did not systematically build an American collection, although they deliberately bought paintings that reminded them of their own history in California. It is no surprise that today the Crocker Art Museum's only Albert Bierstadt, a small view of Yosemite, was acquired as late as 1978: Bierstadt's market during his lifetime was in New York City, not San Francisco or Sacramento.[1]

The major artists (and many minor ones as well) were deeply involved in forming museums and were often directors and curators. Both Frederic Edwin Church and John Frederick Kensett, for example, were trustees of the Metropolitan Museum of Art as well as the subjects of memorial exhibitions, and their paintings were part of the museum's collection from its early days. But after receiving gifts from the artists' estates

5

FACING: Jasper Francis Cropsey, *Eagle Cliff, New Hampshire*, 1872, detail (cat. no. 7).

or from owners of their work, shortly after their deaths, the Metropolitan did not purchase works by these artists until the 1970s. This pattern is typical: once artists cease to be "contemporary" and before they become "historical," most go through a period of being out of fashion; this was especially true for the landscape paintings of Kensett and Church's generation, what is now called the Hudson River School.

Hudson River painting, the core of the Joneses' collection, is defined by most historians as the compositions of American painters centered on New York City from the 1830s to the 1870s. The work of these artists tends to be naturalistic and highly detailed, capturing—both for their contemporaries and for viewers today—an image of the United States that was in the process of transition from a provincial, largely rural young republic to an industrialized, urban world power (as seen from a New York perspective!). At the heart of this vision was imagery along the Hudson River, the great internal waterway that led, through the opening of the Erie Canal, into the heartland of the western United States (what is now the midwest of Ohio through Michigan, along the Great Lakes). When the canal opened in 1825, New York City became the preeminent economic center of the country, with the greatest markets for everything, including art. Even regional artists like George Caleb Bingham, who lived in and painted primarily in Missouri, had a national audience through the distribution of his works in New York.

The founder of this landscape school in the 1830s was Thomas Cole, the first to systematically paint the Catskills, the mountains and valleys a few hours north of the city. While he had

no pupils aside from Frederic Church, his success inspired the emulation of others, both older artists such as Thomas Doughty and Asher B. Durand and a younger generation represented by John Kensett, Jasper Cropsey, and Worthington Whittredge. By the 1860s, these artists had fanned out to other summering holes along the coast, taking their attention to detail and a clear, soft, and calm light with them: William Haseltine and Alfred Bricher were two of many such artists. Genre painters (like Bingham) are considered part of this general style, beginning in the mid-1830s with William Sidney Mount, who painted on Long Island but lived in Manhattan as well. Still life, however, was largely a Philadelphia phenomenon, starting with members of the Peale family. But outliers, if they were similar stylistically, have always been considered part of the group, included within the very relaxed boundaries in both time and space. So, for example, the still lifes of William Harnett and John F. Peto, a good generation later than the classic Hudson River School painters, can still be considered under this generous label. Indeed, given the contacts between California artists and New York, figures like Keith and Hill may be considered as Western extensions of Hudson River painting.

The era that the Hudson River painters depicted was ruptured by the Civil War, a defining event in American history that shaped the United States' path in the future, as a technologically advanced economy driven by wage labor and not slavery, and increasingly connected to the rest of the world. By the 1880s, cosmopolitan artists trained in Europe—such as William Merritt Chase, John Singer Sargent, and James McNeill

Whistler—represented the leading edge of fashion. With few exceptions, the taste for highly finished, realistic studies of daily life fell out of favor, not to return for generations.

There were always exceptions, of course. George Caleb Bingham (never a part of the Hudson River School but from the same period and sharing many stylistic qualities) was the subject of a monographic exhibition at the Museum of Modern Art in 1935. Max Karolik acquired and then gave an enormous collection of mid-nineteenth-century American paintings to the Boston Museum of Fine Arts in 1951 (having built it up from the 1930s), which then formed the basis of exhibitions and the subject of Ph.D. dissertations by a handful of Harvard graduate students beginning in the 1950s—Ted Stebbins, Barbara Novak, and John Wilmerding being the most important. The Boston Museum of Fine Arts's example led to other museums imitating it, most notably the Whitney and the Brooklyn Museum. And various historical exhibitions were timed to important anniversaries or events, like the Hudson-Fulton exhibition at the Metropolitan Museum in 1909 and John Baur's exhibition organized for a State Department tour of Germany in 1953, *American Painting in the Nineteenth Century: Main Trends and Movements.*

But for most of the twentieth century, as museums and collectors began to think of American painting historically, they began with the Ashcan School and the Eight, the pioneers of American realism who, led by Robert Henri, began to exhibit around 1908. A few earlier artists were admitted into this endeavor (notably Winslow Homer and Thomas Eakins), but other major late nineteenth-century artists (like Whistler, Sargent, and Mary Cassatt) tended to be ignored. Also, a place was made for "ancestor portraits": most collections could boast a handful of colonial portraits, which were often the first American paintings a museum might buy.

A good example of the bias toward more recent painting may be seen in the collection of the Wichita Museum of Art, one of the more important collections of American painting west of the Mississippi, which was built by purchase over the course of thirty years, beginning in the 1930s. This superb collection does not contain a single Hudson River School painting; no work dates earlier than the 1870s, and most are later.

By the 1960s, however, the episodic history of collecting Hudson River School painting had begun to change. A sufficient number of dealers, private collectors, scholars, and museums started to show interest in mid-nineteenth-century painting, painting that antedated the cosmopolitanism of the end of the century. The fact that this was only one hundred years since the Civil War and the peak of the Hudson River School's importance is no coincidence. Collecting Hudson River painting was a way of looking back on the beginnings of the modern United States: collecting our "roots," as the title of a highly popular (and very different) television drama of the time suggested. The success of this attention was capped by an impressive series of bicentennial exhibitions throughout the country, by the appointment of John Wilmerding as curator of American art at the National Gallery of Art in 1977 and the exhibitions he organized, beginning in 1980, and by the opening of the new American wing at the Metropolitan Museum, also in 1980.

In California, this upsurge of enthusiasm coincided with real changes in the art world that affected American art in the major centers of Los Angeles, San Diego, and San Francisco, including the establishment of curatorships in American art and the creation of new museums. Preceding all of these developments, however, was Santa Barbara.[2] In 1959, over an intense two-week period, the director of the Santa Barbara Museum of Art, James Foster, went to New York City with the donor Preston Morton (wife of Sterling Morton from Chicago) and chose more than forty paintings that would represent the history of American art from the colonial period to the present. The earliest were portraits by

John Singleton Copley and Benjamin West from 1755–1756, and the latest were a Marsden Hartley and a John Marin from 1933 and two works by Abraham Rattner and Karl Knaths from 1953 and 1959, respectively. Among the paintings were several colonial and early republic portraits; still lifes and landscapes by Benjamin West, James Peale, and others; a group of landscapes by Cole, Cropsey, Kensett (fig. 1), Inness, Whittredge, and Bierstadt; and later nineteenth-century still lifes by Severin Roesen, Peto, and Harnett; portraits by Eakins and Chase; and genre scenes by Homer, Sargent, and Childe Hassam. This roster represents a standard of the most significant nineteenth-century artists, as understood

FIG. 1. John Frederick Kensett (American, 1816–1872),
View of the Beach at Beverly, Massachusetts, 1860. Oil on canvas, 14¼ × 24¼ in.
Santa Barbara Museum of Art, Gift of Mrs. Sterling Morton to the Preston Morton Collection, 1960.68.

FIG. 2. Albert Bierstadt (American, b. Germany, 1830–1902), *Yosemite Valley*,
circa 1863–1875. Oil on canvas, 36⅛ × 52¼ in. *The Haggin Museum, 1931.391.15.*

before 1960. It is, more or less, what we consider the canon today—with a few surprising omissions (no Cassatt) and inclusions (Jerome Myers as an Ashcan artist). And as a record of mid-nineteenth-century Hudson River School painting, the list of artists is not so different from those collected by the Joneses.

The Santa Barbara Museum of Art has one predecessor, and that is the Haggin Museum in Stockton, founded in 1931. This collection is surprisingly rich in classic Hudson River School artists, like Bierstadt (fig. 2), Cropsey, and Kensett, as well as later Impressionists such as Theodore Robinson and Hassam.[3] But these

works were all acquired by Robert McKee and Eila Haggin McKee of New York (the museum is named after Eila's father, Louis Terah Haggin), most likely in the 1880s and 1890s, and at the time they purchased them, they represented a conservative contemporary taste rather than a retrospective, historical taste. Santa Barbara, in 1959, was trying to build a canonical collection of historical American art, while the same artists, in the Haggin Museum, still represented contemporary art. As the director of the Santa Barbara Museum of Art in 1961 noted, "The Museum's total American holdings become a readable ensemble with art-historical sequence."[4]

Any collector, whether a private person or a museum curator, judges works of art against a framework that she or he has learned. We like to think that these standards are stable and universal—that anyone with sense or knowledge would know that a Winslow Homer is better than an Edward Lamson Henry, for example—but, in truth, canons alter over time and respond to changes in scholarship, the market, and larger cultural issues. The very fact that Hudson River painting was out of fashion for more than fifty years, and took another twenty years to be given the official seal of approval by becoming the subject of a definitive exhibition at the National Gallery of Art, should underscore this. While many factors lead to the development of scholarly narratives about who counts and who doesn't, perhaps the primary one (in the age before the internet and Google) is the publication of books with illustrations of the paintings that mattered. Any collector faces a complex interplay between looking at the newest books and their photographs, visiting museum collections,

going to dealers and auctions and seeing what's available, before making a decision to acquire a painting. Any dealer knows that the choice of which paintings to illustrate in a sales catalogue is critical: usually, illustrated pieces will sell first.

Perhaps the most significant publication that shaped the canon was E. P. Richardson's *Painting in America: The Story of 450 Years*, first published in 1956. Richardson was the longtime director of the Detroit Institute of Art and cofounder of the Archives of American Art (with the Detroit collectors Larry and Barbara Fleischman) in 1954. Over the course of his term at the Detroit museum, from 1945 to 1962, Richardson methodically acquired an American collection that represented for him the greatest accomplishments of nineteenth-century American painters, which was then codified in his books. While Richardson's particular interest in American Romantic painting (the subject of one of his first books in 1944) has not generally been supported by later audiences, his survey provided a firm and up-to-date narrative for anyone interested in American art. At the same time, John Baur, first at the Brooklyn Museum and then at the Whitney, began to articulate the specific characteristics of Hudson River landscapes, which he termed "luminism" in 1954.

By 1959, then, when Foster and Morton set out to buy a representative collection of American painting, they had a very good idea of what they were aiming for. Twenty years later, when the Fine Arts Museums of San Francisco were given the American paintings collection of John D. Rockefeller III (for example, fig. 3), the nineteenth century had come into even sharper and more detailed focus.[5] In the development of this

FIG. 3. John Frederick Kensett (American, 1816–1872),
Sunrise among the Rocks of Paradise, Newport, 1859. Oil on canvas, 18 × 30 in.
Fine Arts Museums of San Francisco, Gift of Mr. and Mrs. John D. Rockefeller III, 1979.69.

collection, E. P. Richardson also played a crucial role. Rockefeller and his wife, Blanchette, first began to collect American paintings in 1961, as a form of cultural ambassadorship. By 1964 they had reached out to Richardson to advise them, which he did for the next dozen years as they acquired many more paintings, soon realizing that they were creating a collection intended as a gift to a public museum. After thinking through a number of possibilities, the Rockefellers de-cided that San Francisco was the most suitable: the West Coast had few collections of American art of any quality, and the museums were willing to make a commitment to American art by ap-pointing a curator. In addition, the newspaper critic for the *San Francisco Chronicle*, Alfred Fran-kenstein, was sympathetic: Frankenstein was an experienced Americanist scholar, the authority on William Sidney Mount and the trompe-l'oeil painters Harnett and Peto, as well as a professor

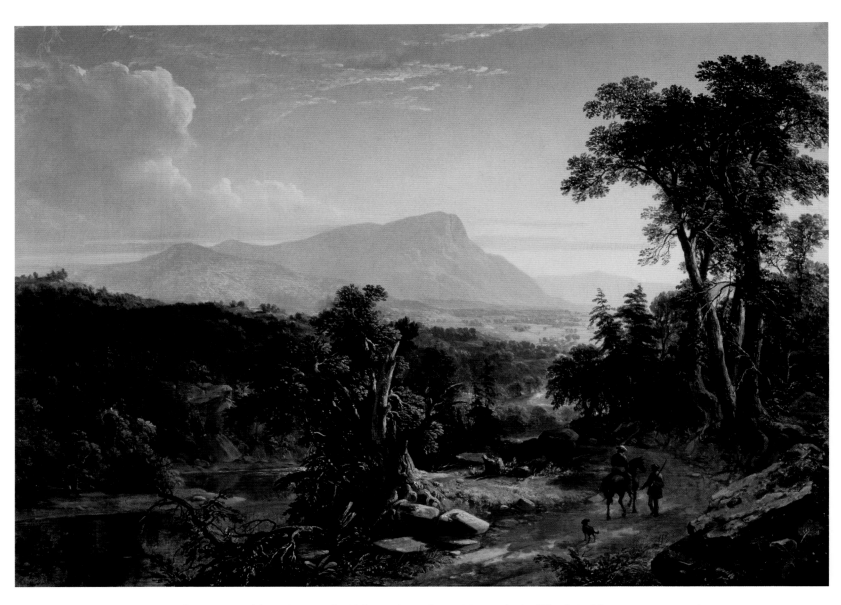

FIG. 4. Asher B. Durand (American, 1796–1886), *Landscape-Composition: In the Catskills*, 1848. Oil on canvas, 30 × 42 in.
San Diego Museum of Art, Museum purchase with funds provided by the Gerald and Inez Grant Parker Foundation, 1974.72.

at Berkeley. That the museums organized a bicentennial exhibition of the Rockefeller collection further demonstrated their commitment, and the Rockefeller gift was announced in 1978.

Two events were catalytic in the development of Rockefeller's collecting taste: the Metropolitan Museum of Art's exhibition *Three Centuries of American Art* in 1965 and the sale later that year of the Fleischman collection, which Richardson had helped build. Richardson's interests give the Rockefeller collection a distinctive flavor, with a large helping of colonial portraits and Romantic works by Washington Allston and William Page. This sort of material is not found in the other major public collections built during this same decade, such as the Cleveland Museum (under Sherman Lee) and the Toledo Museum of Art (under Otto Wittmann). Rockefeller's personal taste, however, comes through clearly in the strength of the Hudson River School landscapes and the many genre scenes by Eastman Johnson.

While it was true that San Francisco lacked a serious collection of American art, other centers housed modest collections (and Santa Barbara maintained the surprisingly strong one). San Diego, beginning in the late 1960s, also built a collection—really, two collections.[6] The San Diego Museum of Art, which opened its doors in 1926, had initially acquired works by John Sloan and Robert Henri, very typical first acquisitions (highlighted by the fact that Robert Henri had visited and worked in San Diego in 1914). Over the years it had assembled a few unassuming examples by important artists. Then in the late 1960s it began to acquire systematically, creating a narrative of American

painting from the 1870s to the 1930s, with all the usual suspects; however, only one Hudson River painting was bought, a landscape by Asher B. Durand (fig. 4). Perhaps the most interesting pieces were two very early abstractions by Konrad Cramer and Morgan Russell. At the same time, in the neighboring Timken Museum, the Putnam Foundation started acquiring a handful of important American paintings, commencing with Martin Johnson Heade and Bierstadt in 1965 and 1966.[7]

This division of labor is not unusual in California; nor is the source and scale of funding, with more modest works acquired out of acquisition funds and donations, and big-ticket items as gifts of foundations. The landscape of philanthropy in Los Angeles, spread out and split into small communities in a way that San Francisco is not, closely resembles the pattern of San Diego, albeit with more spectacular results. Three museums in Los Angeles contain significant American holdings: the Los Angeles County Museum of Art; the Huntington Library, Garden, and Galleries; and the Hammer Museum (the Norton Simon Museum, while it has consequential contemporary California painting, holds no nineteenth-century American art; Norton Simon collected primarily European masters and Asian art). The Hammer's collection is the smallest, with a handful of major works by Eakins, Harnett, and Sargent, and comprises the residue of Armand Hammer's personal collection, which consisted mainly of European art.

The Huntington Library has a profile more like that of the Timken. While the Huntingtons had collected a few American paintings among their British art, the Huntington Library did

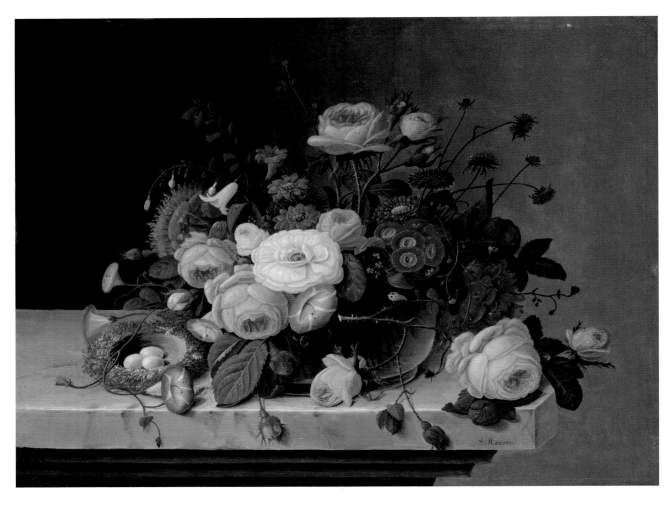

FIG. 5. Severin Roesen (American, b. Germany, 1816–1872?),
Still Life with Flowers and Bird's Nest, after 1860. Oil on panel, 15 × 20 in.
Courtesy of the Huntington Art Collections, San Marino, California, Gift of the Virginia Steele Scott Foundation, 83.8.42.

not become a repository of American art until 1979. Virginia Steele Scott had bequeathed her collection and fortune to a foundation with the intention of setting up a museum in her house and gallery, in a residential neighborhood in Pasadena. When that effort was frustrated, the Virginia Steele Scott Foundation gave the collection to the Huntington Library (for example, fig. 5). Ironically, it included no paintings that Scott herself had bought but instead consisted of paintings (and other works of art) acquired

by the trustees beginning in 1975, first under the direction of the artist Millard Sheets and then with the advice of Maurice Bloch, a professor of American art history at UCLA and an authority on George Caleb Bingham. The gift of nearly forty paintings debuted to the public in 1984. Like the Rockefeller gift to San Francisco or the Morton gift to Santa Barbara, the collection represented a full survey of American art from colonial times to the 1930s, with most of the same artists represented.

Of all these museums, the story of LACMA's collection is the most typical of American museums at large. With no single great benefactor, the American collection was developed slowly and haphazardly, rather like San Diego's. The museum is technically the youngest of the ones discussed here: it was incorporated in the early 1960s and opened its doors in 1965. At the same time, it is one of the oldest, since from 1913 it had been part of what is now solely the Los Angeles County Museum of Natural History in Exposition Park. And as with so many museums (and private collectors) across the country, the first painting acquisition of the museum was an Ashcan painting: George Bellows's *Cliff Dwellers* (1913), a work that had been exhibited at the museum before it was bought in 1916.

With the opening of the museum in 1965, Larry Curry, who had been associate curator of modern art and had organized exhibitions of American art at the old site, was made curator of American art. A support group was organized, the American Art Council, and the museum identified eighteenth- and nineteenth-century American art as an area that needed to be developed. Over the course of the first decade, from 1965 to the bicentennial years, LACMA acquired more than twenty colonial and nineteenth-century paintings, with a group of early portraits by Copley, John Smibert, and Gilbert Stuart, and then a group of landscape paintings by Cole, Bingham, Cropsey, Gifford, and Alexander Wyant (the museum already owned a Kensett), as well as still lifes and genre paintings by Robert S. Duncanson, Severin Roesen, and Emanuel Leutze. In addition, the museum acquired a major Homer and a noteworthy Sargent. The curator, Michael

Quick, played a pivotal role in this history, selecting objects, raising funds, and cultivating collectors, many of whom built excellent collections informed by his eye and taste.

The collectors JoAnn and Julian Ganz were the leading spirits, independent of the taste and advice of any specific curators.[8] They had bought their first American painting in 1964—a character study by the Ashcan artist Robert Henri—and by 1969 displayed their initial efforts in an exhibition at LACMA of thirty-six paintings. Exhibitions in 1973 at Santa Barbara and 1981 at the National Gallery of Art, with more than one hundred works, followed. Between the first and last of these exhibitions, only two works from the first iteration of the collection survived to the last. The Ganzes showed an extraordinary eye for quality and an almost ruthless determination to hone their vision. The final version of the collection was a distillation of an idea of nineteenth-century painting that was refined in its details and execution and poetic in feeling. Not for them were the seductive pleasures of Impressionism or the forcefulness of Realism; they focused on Hudson River painting, and their collection was arguably the best of its kind in the country. The Ganzes developed their collection at more or less the same time as did the Rockefellers, but theirs was much more personal. Moreover, it was built purely from their own taste and knowledge. However, the Ganzes succeeded because they were at the heart of an intellectual community centered on LACMA's American Art Council, which brought in lecturers, visited museums and private collections, went to dealers regularly, and bought and discussed all the latest publications in American

art. The group comprised numerous members of differing degrees of interest and taste. A succession of gifts to LACMA records the names of many of these supporters, a number of whom worked with curator Michael Quick: the Sussmans, Shoemakers, Bartmans, Averys, Carpenters, Liebes, Slavins, Terners, Congdons, and so on (for example, fig. 6).

One other aspect of the museum experience played a central role in the development of an interest in American art within this group, and that was being a docent. Cecile Bartman, for example, who preferred to give funds for acquisitions and enabled the museum to buy many major paintings, was a docent from the moment the museum moved to La Brea. The docent

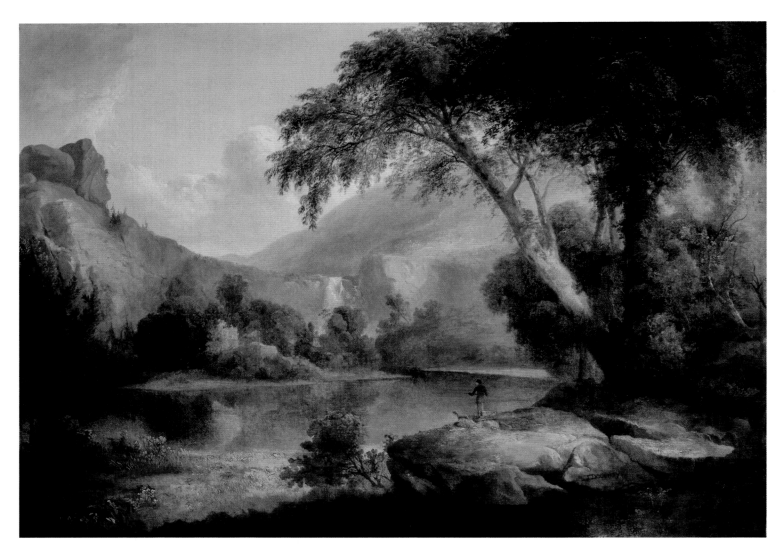

FIG. 6. Thomas Doughty (American, 1793–1856), *White Mountains, New Hampshire*, 1836. Oil on canvas, 25⁵⁄₁₆ × 35⁵⁄₁₆ in. *Los Angeles County Museum of Art, Gift of Camilla Chandler Frost, AC1992.96.1.*

program at LACMA is a rigorous one, involving much mutual critique and serious research on the works to be discussed with the public. The experience of talking about works of art on a nearly daily basis provides excellent lessons in close looking, making docents intimately familiar with the collection, and numerous chances to participate in the mission of the museum, that of making great art available to the public. Bartman's experience was not unique, and a significant number of donors, collectors, and even trustees were graduates of docent training. One of these is Judy Jones.

Judy and Steaven Jones came to Southern California at the start of their careers, seizing the opportunities offered by the postwar expansion of real estate and population. They arrived in the early 1960s, and while Steaven (a graduate of Harvard Business School) was building his business in commercial real estate development, Judy (a graduate of Wellesley) raised their family—and volunteered as a docent at LACMA from 1968 to 1977. She toured the American collections; they joined the American Art Council. Over the course of the next decade, they studied, looked, traveled, and enjoyed a deepening knowledge of American art. By the late 1970s, they were in a position to buy.

Their first purchase was a William Merritt Chase portrait of his daughter Helen, a small bust-and-shoulders rendering seen at Kennedy Galleries in 1982. Starting from zero, they knew they wished to become collectors but were unsure about what kind of collection they aspired to build. Steaven wanted to negotiate the price of the Chase, but Judy insisted that he pay what was asked: "You won't negotiate. It's art," she

tells the story, smiling at her previous naiveté. Once the purchase was settled, they treated themselves to lunch and a bottle of wine.

Shortly afterward, they decided to focus on Hudson River painting and acquired William Trost Richards's *Delaware River Valley* (cat. no. 23). Five years later, they traded the Chase for the Kensett painting *School's Out* (1850; cat. no. 20), and that became the foundation of a collection (with only three exceptions, it is the earliest work they own). Very early on they had bought a portrait by Gilbert Stuart, *Mrs. Pendleton*, and a portrait of Henry Clay by John Wesley Jarvis (cat. no. 18)—Judy is from Kentucky. They were advised to start a collection of federal furniture, which would have more closely matched the earliest paintings they owned; but in the end they were interested in a more panoramic view of American art. The collecting has come in waves, but they have consistently studied the market, reading catalogues, books, and magazines, and viewing auctions. They have been assisted by having a base in Manhattan, a small apartment (for which they have collected American art of the 1920s and 1930s, the date of the building), from which to explore the museums and dealers there. And it was the Metropolitan's collection, along with Boston's and the Art Institute of Chicago's, that they learned most from, an indication of how small California collections still are in relation to those of older museums. They have trained their eye and taste with the same thoughtfulness with which they have developed the collection.

The care with which they have built the collection is evident in many ways. Their first William Bradford is the radiant sunset view of an

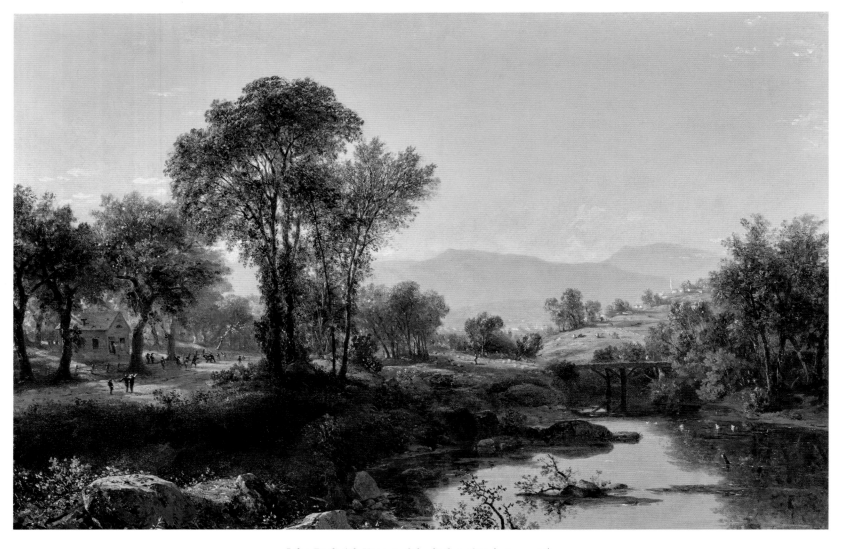

John Frederick Kensett, *School's Out*, 1850 (cat. no. 20).

iceberg (cat. no. 3); years later they acquired their second Bradford, an image of the same iceberg but now part of a larger composition and seen under a different light (cat. no. 4). The first is a sketch made on the spot; the second is a studio composition. Of their two Durands, the first was the small, very lovely and light landscape from 1857 (cat. no. 9). When the op-

portunity came to upgrade it with a larger, more classically composed painting from 1866 (cat. no. 10), they took it—and then, without regretting the new painting, missed the first one. Years later they were able to repurchase the first painting: the freshness of the pre–Civil War painting speaks to a different sensibility, closer to the vision of Thomas Cole, while the later one is

darker and more somber. Both are quintessential Durand works.

The Joneses have been both methodical and passionate. The passion has sustained their collecting over many years, but so has the methodical character of trying to limit it chronologically (roughly 1850 to 1875, with only one or two exceptions at either end). The result is a disciplined, beautiful survey of a coherent moment in American art, focused on the years surrounding the Civil War, when older colonial centers were superseded by the dominant commercial power of the East Coast, New York City. Artists responded in those turbulent years

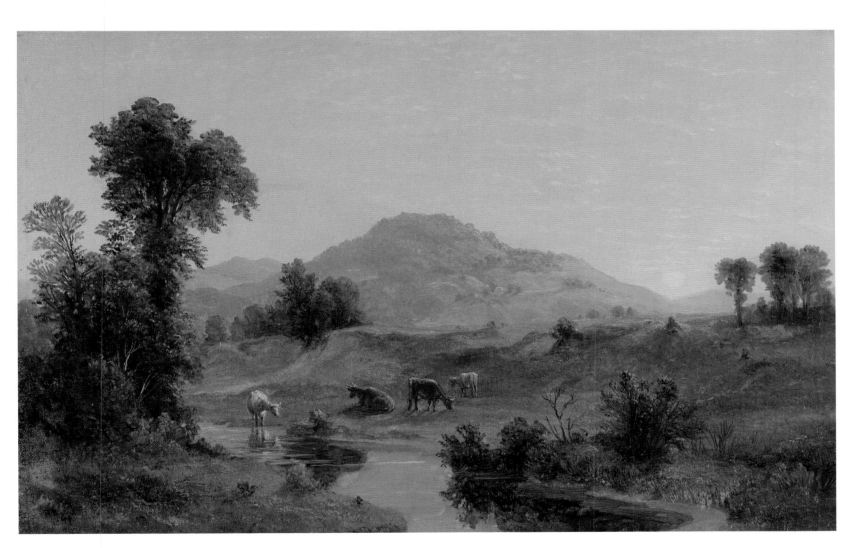

Asher B. Durand, *Pastoral Landscape*, 1857 (cat. no. 9).

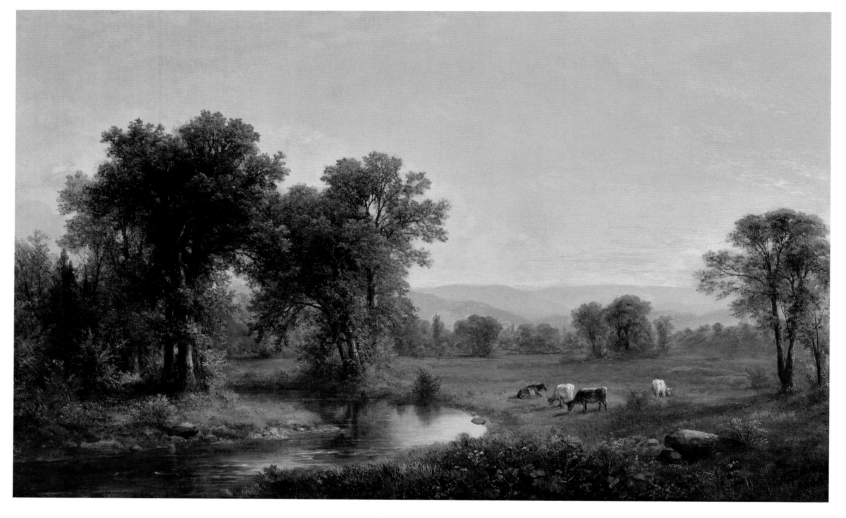

Asher B. Durand, *Pastoral Landscape*, 1866 (cat. no. 10).

by emphasizing the beauty that still surrounded them, found especially in the landscapes of the East Coast.

In a sense, the Joneses have lived through similarly turbulent times, in a moment when California assumed cultural and economic ascendancy in the United States, and a war and civil strife that split the nation (Vietnam and the civil rights movement). Many California collectors (both native and transplanted) responded by collecting views of the California landscape, painted in the early twentieth century, landscapes that recorded the beauties of the state before the development of Los Angeles and the whole of Southern California (the Irvine Collection is perhaps the most prominent example). The Joneses' inclination has been more inclusive and more nationally aware, bringing the East Coast to the West, as they themselves have done.

The Joneses' most recent acquisition (as of the writing of this essay) exemplifies this intersection of personal and artistic histories. Bierstadt's sketch of his family picnicking in the shade of a tree near Oakland, from circa 1873 (cat. no. 1), reminds us of a California past that was literally golden; Bierstadt himself was an East Coast transient who benefited greatly from his views of pristine Western landscapes. At the same time, the acquisition—made after the Joneses had determined that their paintings should go to the Crocker—indicates the change of mindset that occurs when private collectors decide their collection has a public destination. The Bierstadt is the Joneses' first California landscape, but one that fits within all the parameters they have set, of exclusively collecting Hudson River School paintings. The Bierstadt also exemplifies the very reason the Joneses' collection is so meaningful for the Crocker Art Museum, bringing as it does for the first time the first half of the story of American landscape painting, a tradition that flowers in California from the gold rush onward. And what could be a more fitting place than the Crocker, which houses the work of the local son, a painter of iconic contemporary California landscapes, Wayne Thiebaud? The great beauty of a public collection is that all these voices of history and the present, east and west, public and private, can speak together.

NOTES

1. See Richard Vincent West, *Handbook of Paintings* (Sacramento: Crocker Art Museum, 1979).

2. See Santa Barbara Museum of Art, *Two Hundred Years of American Painting, 1755–1960* (Santa Barbara: Santa Barbara Museum of Art, 1961); and Katherine Harper Mead, ed., *The Preston Morton Collection of American Art* (Santa Barbara: Santa Barbara Museum of Art, 1981).

3. The collection also includes works by William Bradford, George Inness, Thomas Moran, Alfred Thompson Bricher, Edward Lamson Henry, William Mason Brown, Edmund C. Coates, William Hart, and David Johnson. See Patricia B. Sanders, *The Haggin Collection* (Stockton, CA: The Haggin Museum, 1991).

4. James Foster, Introduction, in *Two Hundred Years of American Painting*, n.p.

5. See Marc Simpson, with the assistance of Patricia Junker, *The Rockefeller Collection of American Art at The Fine Arts Museums of San Francisco* (San Francisco: The Fine Arts Museums of San Francisco in association with Harry N. Abrams, 1994).

6. See San Diego Museum of Art, *Catalogue of American Paintings* (San Diego: San Diego Museum of Art, 1981).

7. *The Timken Museum of Art: European Works of Art, American Paintings, and Russian Icons in the Putnam Foundation Collection* (San Diego: The Putnam Foundation, 1996).

8. See Los Angeles County Museum of Art, *Chosen Works of American Art, 1850–1924, from the Collection of Jo Ann and Julian Ganz, Jr.* (Los Angeles: Los Angeles County Museum of Art, 1969); and John Wilmerding, *An American Perspective: Nineteenth-Century Art from the Collection of Jo Ann and Julian Ganz, Jr.* (Washington, D.C.: National Gallery of Art, 1982).

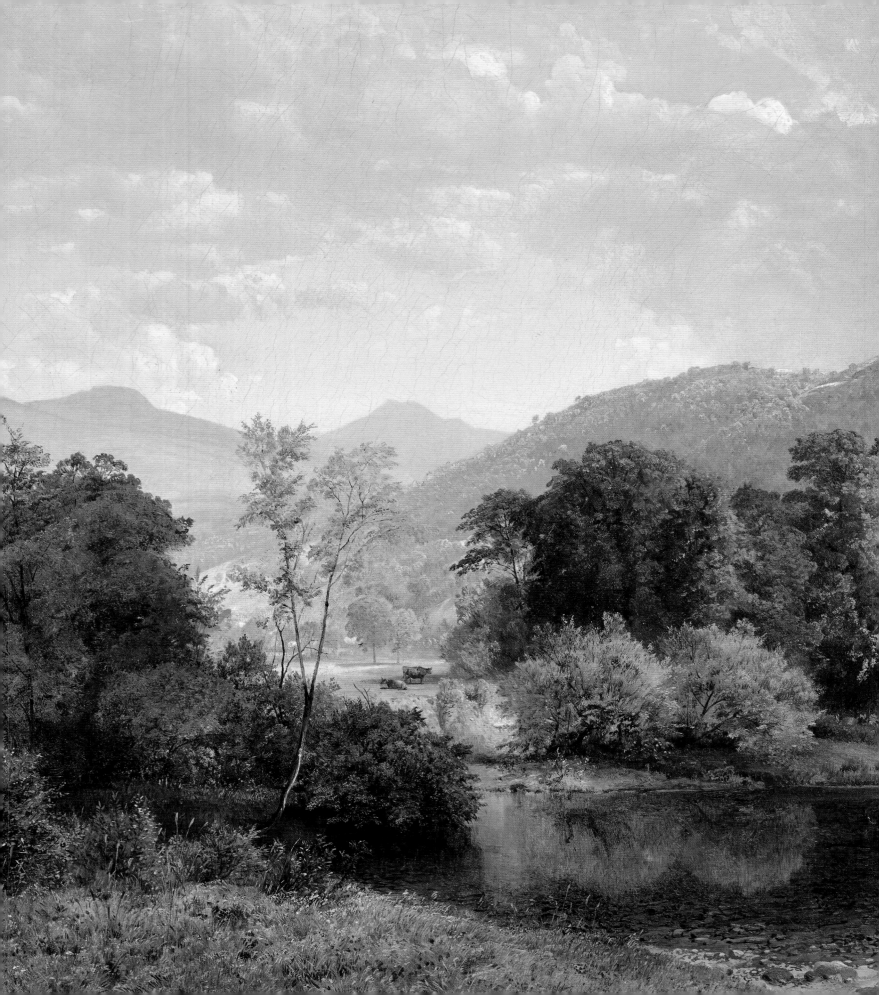

AMERICAN BEAUTY AND BOUNTY

Scott A. Shields

JOHN WESLEY JARVIS's 1814 portrait of a young Henry Clay depicts a confident man on the rise (cat. no. 18). Clay (1777–1852) was thirty-seven when he sat for this portrait, though he had already served two brief terms as a United States senator—the first when he was only twenty-nine. In 1814, he concluded his initial tenure as Speaker of the House of Representatives, a position he held intermittently for a total of ten years. He resigned from Congress that January, so he could travel abroad and help negotiate a peace agreement with the British to bring an end to the War of 1812. In addition to these accomplishments, Clay ran for president in 1824, 1832, and 1844 (and sought his party's nomination twice more) and was secretary of state under John Quincy Adams for four years starting in 1825. From 1831 to 1842, and then again from 1849 until his death in 1852, he served additional terms in the Senate. He was one of the nation's preeminent statesmen and orators, his voice "a magnificent instrument . . . , at times 'soft as a lute' and other times 'full as a trumpet.'"[2]

Though born in Virginia, Clay represented the state of Kentucky and was its "Western Star."[3] In the Jarvis portrait, the earliest work in the Judith G. and Steaven K. Jones Collection of American paintings, he does not engage the viewer but gazes into the distance with a thoughtful yet determined expression. His pale complexion, pink cheeks, and white ruffled shirt stand out against a deep, reddish-brown background that includes architectural elements and a piece of furniture. His left hand, only partially depicted, holds what appears to be a piece of paper, perhaps notes for one of his speeches or a document relating to the end of the war. The portrait fits admirably with one biographer's description of him: "There was a sensitivity and mobility to his face that immediately registered his mood, his thoughts, and his feelings. His facial expressions seemed to change constantly, particularly in conversation. Because of this characteristic, it was said that his portraits rarely achieved a true likeness."[4]

FACING: William Trost Richards, *Delaware River Valley*, 1864, detail (cat. no. 23).

It is significant that Jarvis limned this portrait just as Clay was preparing to help end a conflict that he had played a major role in instigating. A leading War Hawk, Clay used his position as Speaker of the House to get Congress to declare war against Great Britain, the major grievances being that the British violated American rights by blocking trade to France, seized ships and cargo, and impressed American seamen into the Royal Navy.[5] "War," Clay wrote, "calamitous as it generally is, seems to me the only alternative worthy of our Country. I should blush to call myself an American were any other adopted."[6] Clay got his wish, and on June 18, 1812, President James Madison signed the declaration.

The war, which many of the era and since have referred to as the second war of independence, was not a successful campaign for the Americans—at least not until the very end. The Royal Navy's blockade of the East Coast devastated American trade, especially agricultural exports, and the occupation of Washington, D.C., was an assault on national pride, particularly when British forces burned important public buildings, including the "President's House" and the Capitol. The aggressions ultimately resulted in a stalemate, resolved by the December 1814 signing of the Treaty of Ghent, which Clay helped negotiate. Because news of the treaty did not reach America immediately, however, the fighting continued. In January, the British invaded Louisiana and suffered heavy losses at the Battle of New Orleans. This decisive American victory, led by General Andrew Jackson, helped restore American pride and resulted in a new sense of nationalism that did much

to unite the country and heal political and geographic divisions, thus fostering the "Era of Good Feelings."

Within this new spirit of nationalism, Clay and others sought to advance the country's prosperity by putting forth the beginnings of an "American System," an evolving federal-government program designed to encourage the country's agriculture, commerce, and industry. The system included the Tariff of 1816, intended to raise revenue and promote domestic manufacturing, as well as the Second Bank of the United States, to foster commerce. Federal subsidies—generated from revenue raised by the tariff and the sale of public lands—helped to build and maintain internal improvements such as roads and canals. A second tariff, enacted in 1824 to protect American manufacturers, reduced dependency on imports and encouraged sales of American goods.

The American System was a success, bolstering the economy and creating new wealth, which allowed the arts to flower. Clay himself witnessed industry "animated and flourishing" and "commerce, foreign and domestic, active" almost everywhere he turned. There were also "cities and towns springing up, enlarging and beautifying; navigation fully and profitably employed, and the whole face of the country smiling with improvement, cheerfulness, and abundance."[7] Clay recognized these developments in a series of orations given before the Senate in 1832, wherein he spoke resoundingly for three days on the "existing state of the unparalleled prosperity of the country." Surveying the nation, he beheld "cultivation extended, the arts flourishing, the face of the country improved,

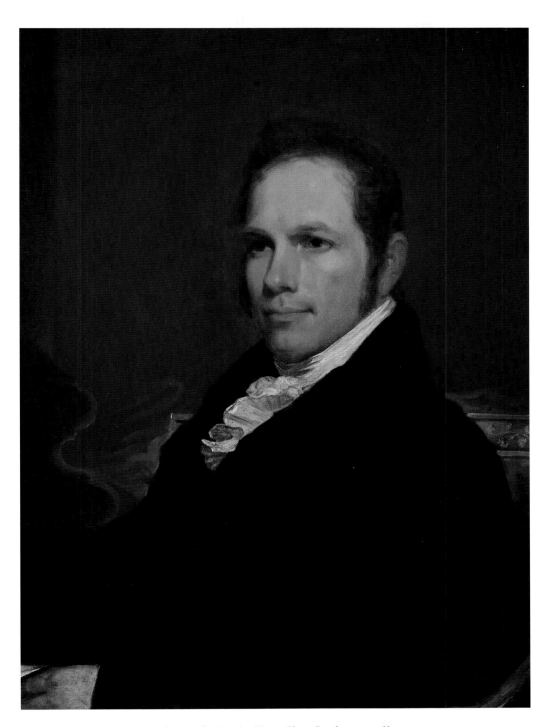

John Wesley Jarvis, *Henry Clay*, 1814 (cat. no. 18).

our people fully and profitably employed, and the public countenance exhibiting tranquility, contentment, and happiness."[8]

Within the context of this rather remarkable, optimistic era, many began to feel that America was now ready—and could afford—to create its own distinctive forms of literature and art. The call started shortly after the signing of the Treaty of Ghent and Andrew Jackson's victory, at the same moment that Congress passed its tariff and authorized its second national bank. In 1816, De Witt Clinton, who four years earlier had run unsuccessfully against James Madison for the presidency and would soon become governor of New York, appealed to the American Academy of the Fine Arts in New York City, hoping to nurture art in the United States and promote the American landscape as subject matter. Clinton's words proved prescient, as two years later English-born artist Thomas Cole immigrated to the United States and set the course for American landscape painting. Clinton opined:

And can there be a country in the world better calculated than ours to exercise and to exalt the imagination—to call into activity the creative powers of the mind, and to afford just views of the beautiful, the wonderful, and the sublime? Here Nature has conducted her operations on a magnificent scale: extensive and elevated mountains— lakes of oceanic size—rivers of prodigious magnitude—cataracts unequaled for volume of water—and boundless forests filled with wild beasts and savage men, and covered with the towering oak and the aspiring pine.

This wild, romantic, and awful scenery

is calculated to produce a correspondent impression in the imagination—to elevate all the faculties of the mind, and to exalt all the feelings of the heart.[9]

Shortly thereafter, the American writer James Kirke Paulding argued the same point, urging Americans to free themselves from the "servile imitation" of European prototypes and to concentrate on American scenes and events. Paulding endorsed indulging those "little peculiarities of thought, feeling and expression which belong to every nation," reasoning, "By borrowing from nature and not from those who disfigure or burlesque her—he may and will in time destroy the ascendancy of foreign taste and opinions and elevate his own in the place of them."[10]

During this same period, important art schools opened or would soon open, making the establishment and furtherance of indigenous painting traditions seem possible. The American Academy of the Fine Arts, a bastion of Classicism and the place where Clinton delivered his lecture, was established in 1802. Three years later, the Pennsylvania Academy of the Fine Arts opened in Philadelphia to "unfold, enlighten, and invigorate the talents of our Countrymen."[11] In 1825, artists and architects, including landscapists Thomas Cole and Asher B. Durand, formed the beginnings of the National Academy of Design. Nine years later, William Dunlap published his *A History of the Rise and Progress of the Arts of Design in the United States*, a first-of-its-kind biographical dictionary with commentary that acknowledged Americans in the visual arts.

The call for nationalism continued in earnest until the clouds of civil war began to darken American skies, intensifying not only in the

visual arts but in all realms of culture. The influential political writer John L. O'Sullivan, in an 1839 article in *The United States Magazine and Democratic Review*, hoped for a literature that would "breathe the spirit of our republican institutions . . . and speak the soul—the heart of the American people." Of writers, he asked:

> When will they be inspired by the magnificent scenery of our own world, imbibe the fresh enthusiasm of a new heaven and a new earth, and soar upon the expanded wings of truth and liberty? Is not nature as original—her truths as captivating—her aspects various, as lovely, as grand—her Promethean fire as glowing in this, our Western hemisphere, as in that of the East?[12]

The Horticulturist, and Journal of Rural Art and Rural Taste, edited by landscape designer Andrew Jackson Downing, argued similarly that Americans should take their cues from the native landscape and use local plants in their gardens rather than import foreign varieties.[13] Politicians even beseeched men and women to wear American-made clothing. Early in his career, Clay himself introduced a "homespun" resolution to induce the Kentucky legislature to don only articles of American manufacture. He later would ask in one of his 1832 speeches, "Are the fine graceful forms of our fair countrywomen less lovely when enveloped in the chintzes and calicoes produced by native industry, than when clothed in the tinsel of foreign drapery?"[14]

Visual artists and literary figures certainly shared these ideals. In his 1836 "Essay on American Scenery," Thomas Cole (now having spent eighteen years in the United States) wrote with passion about the American landscape's importance and power: "It is a subject that to every American ought to be of surpassing interest; for, whether he beholds the Hudson mingling waters with the Atlantic—explores the central wilds of this vast continent, or stands on the margin of the distant Oregon, he is still in the midst of American scenery—it is his own land; its beauty, its magnificence, its sublimity—all are his; and how undeserving of such a birthright, if he can turn towards it an unobserving eye, an unaffected heart!"[15] Just a year later, writer Ralph Waldo Emerson announced in a lecture, "Our day of dependence, our long apprenticeship to the learning of other lands, draws to a close."[16]

Artists and writers would continue to promote the homegrown for many years to come. In 1855, Asher B. Durand sought to convince his fellow artists of the importance of depicting native places and scenes in his series of "Letters on Landscape Painting," published in the influential art journal *The Crayon*:

> Go not abroad then in search of material for the exercise of your pencil, while the virgin charms of our native land have claims on your deepest affections. Many are the flowers in our untrodden wilds that have blushed too long unseen, and their original freshness will reward your research with a higher and purer satisfaction, than appertains to the display of the most brilliant exotic. . . . I desire not to limit the universality of the Art, or require that the artist shall sacrifice aught to patriotism; but, untrammeled as he is, and free from academic or other restraints by virtue of his position, why should not the American landscape

painter, in accordance with the principle of self-government, boldly originate a high and independent style, based on his native resources?[17]

THE ESSENCE OF THE OBJECT SEEN

Within this early period of exceptional nationalism and economic growth, American artists began to pursue still-life, landscape, and genre painting as well as sculpture, accommodating a new group of patrons desirous for art beyond portraiture. Prior to this time, art for its own sake had been viewed as a luxury, even a vice, as citizens prided themselves on being virtuous and restrained, qualities communicated quite clearly in the directness—indeed, often severity—of their portraits. Orators of this earlier era argued, "To be free we must be virtuous," deeming this trait a necessity in maintaining a republican system of government.[18] Historian Neil Harris explains, "As luxury was the deadly corruption which could poison national virtue, and as the fine arts—foreign, expensive, aristocratic, superfluous—epitomized such luxury, many patriot hearts were sealed against their American existence."[19]

Most people of this period, including the American founding fathers, believed that only mature civilizations could—or should—promote or patronize art. President John Adams, for instance, believed that the arts had nothing to contribute to American virtue.[20] Thomas Jefferson held a similar view. Though Jefferson deemed landscape gardening and architecture worthy of attention (which is predictable, since Jefferson was also an architect), he thought paintings and sculpture too expensive for the current state of American society. "It would be useless therefore and preposterous for us to endeavor to make ourselves connoisseurs in those arts," he stated. "They are worth seeing, but not studying."[21] Patrons for types of art other than portraiture were, consequently, woefully few, a constraint that American visual artists of the period keenly felt. Revolutionary War painter John Trumbull bemoaned this lack of support to a budding artist, grumbling, "You had better learn to make shoes or dig potatoes than to become a painter in this country."[22]

But within the period of economic prosperity following the War of 1812 and then the implementation of the American System, such ideas began to change. With the economy flourishing, development and industrialization increasing, the country expanding, and the population growing, it was an opportune time to make money, and the pursuit of wealth soon began to eclipse the self-imposed need for restraint. When French diplomat and historian Alexis de Tocqueville visited the United States in the early 1830s and then published his *De la démocratie en Amérique* (*Democracy in America*), he described with astonishment what had become a pervasive American restlessness to get ahead, even amid such natural abundance. "It is strange to see with what feverish ardor the Americans pursue their own welfare," he stated, "and to watch the vague dread that constantly torments them lest they should not have chosen the shortest path which may lead to it."[23] At the same time—and with seeming incongruity—Americans remained profoundly concerned with their morality and spiritual well-being, the 1830s having been called the greatest evangelical revival in Ameri-

can history.[24] While aghast at American ambition, de Tocqueville also noted Americans' "fanatical and almost wild spiritualism," as well as the fact that itinerant preachers everywhere were hawking "the word of God from place to place."[25] It was in large part because of Americans' "fanatical spiritualism" that they expected their art to serve the public good by invoking intellectual or religious associations.

In the realm of landscape painting, artists certainly sought such associations. Though devoted in their quest to be true to nature, they simultaneously aimed to communicate by what they included or left out, enabling their paintings to be both naturalistic and didactic. Thomas Cole set the tone with his depictions of the American wilderness, which were painted in the second quarter of the nineteenth century. These works celebrated nature with topographical accuracy and yet were capable of moralizing, inducing piety, and even appealing to viewers' sense of nationalism. His patrons expected both. According to historian Alan Wallach, "They [Cole's patrons] believed that art must ally itself with patriotism and morality; they distrusted anything that smacked of extravagance or luxury, which they associated with old world decadence; and they had little tolerance for the fantastic or the idealized, insisting that modern landscape painters paint 'real' landscapes."[26] Cole also found such allusions compulsory. He believed that the "contemplation of scenery" could be a "source of delight *and* improvement," and he argued that art "should be pure and lofty . . . , an impressive lesson be taught, an important scene illustrated—a moral, religious or poetic effect be produced on the mind."[27]

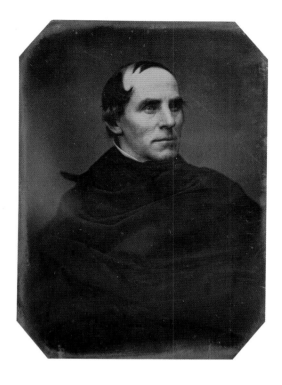

FIG. 7.
Mathew B. Brady (American, 1822–1896), *Thomas Cole*, circa 1845. Half-plate daguerreotype on silver-coated copper plate, 5⅜ × 4 in.
National Portrait Gallery, Smithsonian Institution; gift of Edith Cole Silberstein, NPG.76.11.

Today, Cole is known as the "father" of the Hudson River School of landscape painting (fig. 7). Though Cole died in 1848, before landscape painting reached its pinnacle of esteem, he was nevertheless able to witness its evolution from relative nonexistence to widespread appreciation by critics and the public alike. Only a decade after Cole's death, *The Crayon* substantiated how far landscape painting had come in a review of the annual exhibition at the National Academy of Design: "According to the present exhibition, landscape painting seems to be, for our time, the principal outlet for artistic capacity, being the only department of Art encouraged by the community. If there be an Art of a nobler import to us it is not sufficiently developed, or is perhaps dependent for encouragement upon a state of civilization quite different from the present one."[28]

In America, the representation of the land made logical sense, since not only was the terrain grand—with places that Cole described as uniting "the picturesque, the sublime, and the magnificent"—but also the United States did not have Europe's long-documented history to draw upon. Lacking an extensive, usable past, as well as its accompanying vestiges of antiquity, artists turned to nature.[29] As Cole reasoned, "The Rhine has its castled crags, its vine-clad hills, and ancient villages; the Hudson has its wooded mountains, its rugged precipices, its green undulating shores—a natural majesty, and an unbounded capacity for improvement by art."[30] Journalist John L. O'Sullivan took this thinking one step further, relishing that America was "unsullied by the past." O'Sullivan, in fact, claimed to have "no interest in scenes of antiquity, only as lessons of avoidance of nearly all their examples."[31] America, by contrast, was filled with youthful promise, and though the land itself offered its own history, it was still relatively undeveloped—at least by European standards—and boasted seemingly unlimited potential. Cole recognized, "American associations are not so much of the past as of the present and the future."[32] O'Sullivan characterized the country as "*the great nation* of futurity."[33]

The Hudson River School that Cole fathered describes landscape painters centered around New York City, who became known for their depictions of the Hudson River Valley and surrounding regions—including the Catskill, Adirondack, and White Mountains and, ultimately, locales much farther afield, such as the Canadian Maritimes, the American West, and even South America. Despite differences in the topography that these artists depicted, the fact that they all

focused on the landscape and pursued a highly polished, detailed technique provided enough consistency for the artists to be collectively defined in the late 1870s as the Hudson River School, the moniker applied in the school's decline, just as the painters themselves were being supplanted by artists of the Barbizon School and, shortly thereafter, the Impressionists.[34] The Jones Collection includes key artists associated with the Hudson River School's first generation (Asher B. Durand and Thomas Doughty) as well as the second (Albert Bierstadt, Alfred Thompson Bricher, Jasper Cropsey, Sanford Robinson Gifford, William Hart, John Frederick Kensett, William Trost Richards, and Thomas Worthington Whittredge). United in their focus on landscape and in their concerns with light and atmosphere, these artists rendered scenes ranging from romantic to realist, intimate to expansive, and stormy to eternally calm. Such variations were well recognized at the time, such as in *The Knickerbocker*'s 1833 description of Cole's favored subjects as being "the grandeur, the wild magnificence of mountain scenery" and Thomas Doughty's as "all that is quiet and lovely, romantic and beautiful."[35] Doughty's late 1820s *Adirondack Mountain Scene* fits this description admirably (cat. no. 8). Quietly pastoral, it features a stream and framing trees, including one that has fallen. A hunter surveys the scene, rifle in hand, looking across the water toward a modest house with a figure out front chopping wood. Given the hunter's physical separation from the home, he likely does not live there, though he surely envies it as a place of safety and warmth, the latter indicated by smoke gently emanating from the chimney.

Comparisons were also made between Cole's

FACING: Thomas Doughty, *Adirondack Mountain Scene* (*Catskill Scenery*), circa 1828 (cat. no. 8).

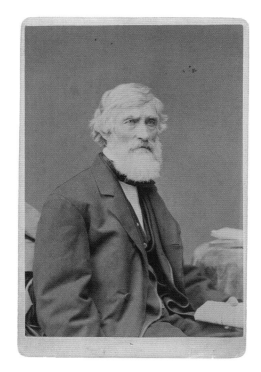

FIG. 8.
Abraham Bogardus
(American, 1822–1908),
Asher B. Durand, circa 1869.
Photographic print,
6⅝ × 4⅜ in.
*Miscellaneous Photographs
Collection, Archives of American
Art, Smithsonian Institution.*

work and that of Durand (fig. 8), the latter assuming the mantle of the country's leading landscape painter in the years immediately following Cole's death. But important differences between their work existed as well—Cole's was more didactic, Durand's romantic—as the *New York Evening Post* recognized in 1847:

> The productions of Cole appeal to the intellect, those of Durand to the heart. . . .
>
> Both of these artists are undoubtedly devoted students, but while one revels upon the whole of a landscape, the attention of the other is invited by an isolated feature of peculiar beauty. Durand paints the better study from nature, so far as individuality is concerned, but Cole produces with greater truth the uncommon effects observable in nature. . . .
>
> The conclusion of the whole matter then

32

AMERICAN BEAUTY AND BOUNTY

is just this: Cole and Durand are among the master artists of the age, and will ever be remembered with pleasure by all lovers of the beautiful and true in art and nature.[36]

HIGH AND HOLY MEANING

Cole, Durand, and other artists of the Hudson River School shared pervasive, transcendental beliefs that equated nature with the Divine. Not only did nature declare God's glory—his immanence pervading every rock, flower, and tree—but also it offered the reverent a means to connect to him. As a literary and philosophical movement, transcendentalism began in the late 1830s, with pioneering writer Ralph Waldo Emerson and other authors perceiving correspondences between the natural and spiritual realms. Painters professed similar views, which were influenced by, as well as paralleled and sometimes predated, those of the writers. Cole's 1836 "Essay on American Scenery," for instance, was coincident in date with Emerson's "Nature." Both associated the natural world with the Creator, though with a distinction. For Emerson, God dwelled within and existed as nature, with "particular natural facts . . . [being] symbols of particular spiritual facts."[37] Cole's transcendentalism was different; he saw nature not *as* God, but as His handiwork, and it was through nature—especially in the Catskills—that Cole best achieved communion with him.[38] He wrote, "In gazing on the pure creations of the Almighty, he [the viewer] feels a calm religious tone steal through his mind, and when he has turned to mingle with his fellow men, the chords which have been struck in

that sweet communion cease not to vibrate."[39] Cole's paintings manifest his beliefs, most obviously when he depicted a solitary figure alone with nature, contemplating its holiness (for example, fig. 9).

Transcendentalist painters and writers maintained their parallels for many years to come. Durand's 1855 "Letters on Landscape Paint-

ing," which included transcendental sentiments throughout, appeared shortly after Henry David Thoreau's 1854 transcendental paean *Walden; or, Life in the Woods*. Like Cole, Durand believed that there was more to the representation of nature than meets the eye. "We see, yet perceive not," he explained, "and it becomes necessary to cultivate our perception so as to comprehend

FIG. 9. Thomas Cole (American, b. England, 1801–1848), *View of Monte Video, the Seat of Daniel Wadsworth, Esq.*, 1828. Oil on wood, 19¾ × 26¹⁄₁₆ in. *Wadsworth Atheneum Museum of Art, Hartford, CT, Bequest of Daniel Wadsworth, 1848.14. Image by Allen Phillips, Wadsworth Atheneum.*

the essence of the object seen."[40] For Durand, artists' reverent and faithful attention to nature had the power to awaken profound, elevated emotions. He believed that God offered to every "true and faithful artist—the STUDIO of Nature," and that "the true province of Landscape Art is the representation of the work of God."[41] As was true of Cole, his ideas are evidenced in his paintings, which manifest his reverence in their verisimilitude to nature's forms. Durand wrote of nature's influence "on the mind and heart":

> The external appearance of this our
> dwelling-place, apart from its wondrous
> structure and functions that minister to our
> well-being, is fraught with lessons of high
> and holy meaning, only surpassed by the
> light of Revelation. It is impossible to con-
> template with right-minded, reverent feel-
> ing, its inexpressible beauty and grandeur
> . . . without arriving at the conviction
>
> —*"That all which we behold*
> *Is full of blessings"*—
>
> that the Great Designer of these glorious
> pictures has placed them before us as types
> of the Divine attributes, and we insensibly,
> as it were, in our daily contemplations,
>
> —*"To the beautiful order of his works*
> *Learn to conform the order of our lives."*[42]

In painting, transcendental ideals seem most epitomized in the work of landscapists usually referred to today as Luminists, a group of painters connected to—or that emerged from—the Hudson River School. Some art historians have viewed "Luminism"—a term applied not by the artists themselves but by art historians in the mid-twentieth century—as a variation on the Hudson River School style, others as emblematic of its final phase.[43] Such paintings were generally created later in the Hudson River School's evolution, between 1850 and 1875. Typically less grandiose or sublime, the scenes are more quiet, horizontal, and focused on water. The works are most noteworthy for their diffuse depiction of atmosphere and white or golden light, which served as a metaphor for God's presence. This light permeated not only landscapes but marine and boat subjects and some genre scenes as well.

Though paintings described as Luminist were most consistently limned in the East, artists worked in similar styles elsewhere, even as far west as California. Quintessential East Coast practitioners included Martin Johnson Heade, Fitz Hugh Lane, Sanford Robinson Gifford, and John Kensett, the latter two represented in the Jones Collection. Other painters in the Jones Collection also associated with Luminism—or who produced paintings with Luminist subjects and light—include Alfred Bricher, William Bradford, Jasper Cropsey, William Hart, and William Trost Richards, though these artists at times produced work more in keeping with the Hudson River, or even Barbizon, School styles. The artists' paintings also varied in the locales they depicted, the times of day they portrayed, and in the weather effects they captured.

Of all the paintings in the Jones Collection, Gifford's 1860 *Lake Champlain* fits the Luminist label best in its evocative, all-pervasive light (cat. no. 13). A native of New York, Gifford became well known for his ability to render atmospheric effects, a skill that is on full display in the immediacy of this small oil sketch. The scene

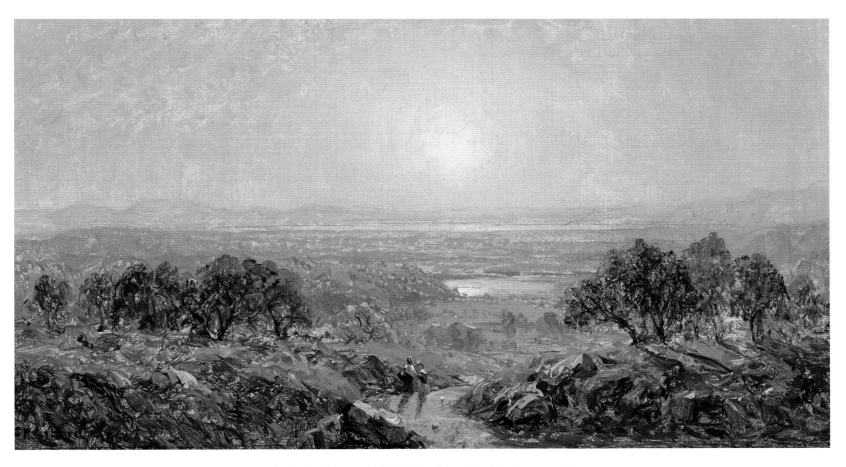

Sanford Robinson Gifford, *Lake Champlain*, 1860 (cat. no. 13).

depicts the wider sweep of the Lake Champlain Valley, which lies between the Green Mountains of Vermont and the Adirondack Mountains of New York. Trees frame the view like theater curtains, the foreground opening into an expansive distance flooded by light. Distant hills are only penciled in, contrasting with the juicy foreground brushwork used to render boulders and foliage. A woman and child provide narrative interest, the pair following a path descending into the valley, the woman with a basket in hand.

William Hart's *Coast of Maine* (1868; cat. no. 15), along with William Bradford's *Coast of Labrador* (northern Newfoundland, 1866; cat. no. 3)

and *Icebergs* (circa 1868; cat. no. 4), also have strong Luminist elements in both their coastal subject matter and their illumination. Hart's includes all the typical ingredients, but its rocky shore and crashing waves make it more dynamic than most, and cows, boats, and a lighthouse add human components to nature's grandeur. Bradford's paintings likewise fit the Luminist label in their gorgeously reflective water and redolent light, yet they are romantic, active, and human-centered as well, the people, boats, and buildings as much of a focus as the topography. Bradford was the first American artist to paint Arctic seascapes such as these, and he later

published an account of his excursions. The dilapidated state of the architecture in the Labrador scene suggests that nature will ultimately prevail and reclaim the buildings' site. Bradford also seems to equate humanity's handiwork with God's, the silhouette of the boats mimicking that of the iceberg.

LOVING STUDIES OF NATURE

To be sure, landscape painters believed in creating a "composition," rather than mirroring nature directly, though they were certainly intent on getting the details right. This practice started with Cole, who wrote to his patron Robert Gilmor of Baltimore in 1826: "If I am not misinformed, the finest pictures which have been produced, both Historical and Landscape, have been compositions. . . . If the imagination is shackled, and nothing is described but what we see, seldom will anything truly great be produced either in Painting or Poetry." This declaration did not mean that Cole thought it necessary to depart from the specifics of nature to produce such compositions. "On the contrary," he explained, "the most lovely and perfect parts of Nature may be brought together, and combined in a whole that shall surpass in beauty and effect any picture painted from a single view."[44] Cole's friend Durand shared a similar philosophy, which informed his written essays as well as his artwork.

The idea of combining nature's best elements was not, however, in keeping with the precepts of English critic John Ruskin, whose first volume of *Modern Painters* (1843) revealed him to be a staunch advocate of truth to nature. Ruskin believed that the artist's personality, along with evidence of the artist's hand, should

remain invisible. He opposed artists who portrayed nature in a general way or according to art-historical tradition, especially in the realm of landscape painting, which to him included many great landscape painters of the past. Even those of the stature of Claude Lorrain and Salvator Rosa, Ruskin believed, were intent on honoring themselves, not God. "The power of the masters," he cautioned, should be "shown by their self-annihilation."[45]

To Ruskin, it was a mistake for artists to prioritize the rules of composition over their observation of the natural world. Artists, he believed, should not modify God's work or cast their own "shadow" on it, but be disciples of nature as it appeared.[46] For Ruskin, simple, "uncombined" landscapes held the most powerful "appeal to the heart," with every alteration or omission from nature's realities coming at the cost of grandeur and beauty.[47] Ruskin wanted artists to express the specific characteristics of "every class of rock, earth, and cloud . . . with geologic and meteorologic accuracy," paying attention to the smallest details and pursuing an "earnest, faithful, loving study of nature as she is, [and] rejecting with abhorrence all that man has done to alter and modify her."[48]

American landscape painters were certainly familiar with Ruskin's ideas. Of all the landscape painters in the Jones Collection, the one who most closely followed Ruskin's dicta was William Trost Richards, who is represented by an 1864 oil, *Delaware River Valley* (cat. no. 23), and by an 1874 watercolor, *Sundown, Atlantic City* (cat. no. 24), the latter more Luminist in style and typical of the artist's works from the late 1860s and beyond, when he worked increasingly in watercolor and

William Trost Richards, *Delaware River Valley*, 1864 (cat. no. 23).

painted views of the sea. Connected in his earlier work to both the Hudson River School and American Pre-Raphaelites, Richards was born in Philadelphia and became known for his extraordinarily meticulous technique. His paintings embodied Ruskin's statement that "if you can paint *one* leaf, you can paint the world."[49] In the foreground of *Delaware River Valley*, every blade of grass, leaf, and rock is rendered with remarkable fidelity. Even the trees on the hills in the middle distance are exacting. Despite the dizzying abundance of detail, the scene remains quietly bucolic, denying any sense of turbulence generated by the ongoing Civil War.

Thomas Worthington Whittredge's painting *Ducks on a Pond* (cat. no. 28) is from the same year as Richards's *Delaware River Valley* and is equally tranquil, though the prominent tree in the foreground, with its dead and broken limbs draped in doleful red vines, hints at loss. The

painting is also nearly as detailed, despite its looser application of pigment overall. Each leaf is admirably captured through a single stroke of the brush, and the red and orange autumn foliage and corn shocks acknowledge that another year—and hopefully the war—will soon end.

Like Whittredge, most American landscapists of the period worked in a style looser than that of Richards, and many also incorporated greater romanticism, as few artists were willing to assume such a taxing level of detail or take Ruskin's ideal of truth to nature quite so far. Durand, for instance, who made fastidiously

beautiful oil sketches directly from nature, certainly agreed that art must be true to its source; he felt strongly that the true and beautiful were "inseparably connected."[50] He believed as well that one must never profane nature's "sacredness" by willfully departing from its truth.[51] But Durand also held that once an artist came to know nature's truths, he or she could be selective about what to present and in what combinations. He urged young artists, "Learn to read the great book of Nature, to comprehend it, and eventually transcribe from its pages, and attach to the transcript your own commentaries,"

Thomas Worthington Whittredge, *Ducks on a Pond*, 1864 (cat. no. 28).

suggesting that the novice artist at first accept all that nature presented until he or she, as Durand put it, had become "intimate with her infinity."[52] Then and only then was it permissible to omit portions of nature's wealth.

In Durand's estimation, art should be representative, not simply imitative, meaning that it needed to "satisfy the mind."[53] Though generally less inclined than Cole to use his landscapes to moralize, educate, or deliver religious sermons, Durand, like other Hudson River School artists, nevertheless maintained that his paintings had the potential to communicate broader ideas.[54] Copying nature with great technical proficiency was not enough, as he believed that such rendering alone was "destitute of all that awakens thought or interests the feelings" and would likely prove to be "false to Nature."[55] Durand did not intend to portray an invented world, but he did hope to reveal "deep meaning."[56] He called the type of landscape painting that Ruskin promoted "view painting," which in his mind was inferior, as it precluded "the exercise of the creative power in invention and composition."[57] He sought idealism, not realism, defining the latter as the "acceptance of ordinary forms and combinations as found."[58] Though nature came first, ideas and art were never far behind, which distanced his views from Ruskin's. In his "Letters on Landscape Painting," Durand challenged the critic directly:

Much has been said by writers on Art as well as artists, in disparagement of what they call *servile imitation* of Nature, as unworthy of genius and degrading to Art, cramping invention, and fettering the imagination, in short, productive only of

mere matter-of-fact works. What is meant by servile imitation, so called, is difficult to understand. If its meaning is limited to that view of realism which accepts commonplace forms and appearances, without searching for the ideal of natural beauty, the objections are valid.[59]

Others of the era felt similarly, and not only the landscape painters. In a critique of Ruskin's *Modern Painters*, volume 1, for the *North American Review*, Franklin B. Dexter asserted, "The true purpose of art . . . is not simply to put into gilt frames that which can be seen at any time, or even but occasionally, by looking out of doors; but to select the finest realities of nature and combine them into one consistent ideal scene."[60] Andrew Jackson Downing in *The Horticulturist* shared the assessment on a practical level, arguing the need to combine the real and the ideal in the cultivated landscape by selecting from natural materials that abound in a particular place and reorganizing the best sylvan features to bring about a "higher beauty of development and a more perfect expression than nature itself offers."[61]

Durand himself sought nature's "utmost perfection," both in the parts of the landscape he chose to portray and in how he presented those elements. "To compose the ideal picture . . . ," he explained, "the artist must know what constitutes the perfection of every object employed, according to its kind, and its circumstances."[62] This practice did not mean rendering every leaf on every tree, as Richards did, but instead called for representing the "distinctive character" of a given tree's foliage.[63] In Durand's estimation, all of the fundamental elements for an ideal representation of nature were inherent within it, and

by selecting and combining wisely, alteration of the truth became unnecessary. He wrote:

> Nature herself is unequal, in the eye of Art. It is the province of Art, then, and all the license that the artist can claim or desire, is to choose the time and place where she displays her chief perfections, whether of beauty or majesty, repose or action. Let her sittings be thus controlled, and the artist will have no occasion to idealize the portrait, no need to shape her features on his classic model—or eke out an expression that he does not see.[64]

Two paintings by Durand in the Jones Collection manifest his approach. Each is a pastoral landscape, though painted almost ten years apart, the smaller in 1857 and the larger in 1866 (cat. nos. 9, 10)—shortly before, and just after, the Civil War. The paintings are equally bucolic; both include a stream flanked by trees and cows. Because of the cattle, we know that this land is domesticated, and that people cannot be far away, though in neither painting are human figures visible. As might be expected, the smaller painting is more immediate, being sketchier in its handling and less polished than the larger work. It includes a looming hill and setting sun. The larger painting also features hills, but much farther in the distance. In this view, the foreground contains flowers, which bloom in this Edenic place—an indication, perhaps, of hope in the wake of the war.

GOD'S BOUNTY

Like their landscape-painting colleagues, still-life painters of the era practiced a highly detailed, polished technique. They likewise sought to be true to nature, its diverse and beautiful bounty being their favored subject matter, at least early on. Also like landscapists, who aimed to transform nature into art by selecting and combining the perfect setting with ideal geologic and arboreal specimens, still-life painters strove to idealize or romanticize their works through their selection and combination of objects. With their landscape confrères they shared as well a cheerful, midcentury confidence, their still lifes evincing their faith in America and the potential of its terrain. Art historian William H. Gerdts has acknowledged, "The New World was recognized as reflecting the glories and thus the bounties of the deity in its broad rivers and streams, abundant forests, majestic mountains, and the like. Thus, just as landscape painting flourished, so did images of the copious yield of that land."[65]

Initially, however, still lifes seemed less able to educate or moralize in the way that landscapes or scenes of daily life did, causing them to rank low in the hierarchy of painting genres. Critic Daniel Fanshaw, for instance, placed them beneath paintings of animals and cattle, and above only sketches and copies.[66] According to Fanshaw, the still life's merit was in its "*exactness of imitation*," which was "fascinating" and "intelligible to all," but not the primary aim of painting.[67] Art needed to be more than a transcript of the scene or objects at hand. Because Fanshaw and others of the era denied still lifes a symbolic or instructional capacity, the genre did not assume a more elevated position until later in the nineteenth century, when art for art's sake and the physicality of the artwork itself increased in importance. It was also later that artists and

critics began to recognize the didactic potential of an artist's choice-making and careful selection of subject matter, thus according still-life paintings the same communicative capacity as other genres and elevating them from being imitative, decorative, and documentary to a higher realm of art.

American still-life painting began with the Peale family in Philadelphia, Raphaelle Peale being the first American still-life specialist. His paintings, the earliest dating to the 1810s, along with those by his uncle, James Peale, primarily featured fruit and other edibles (fig. 10). These works set the stage—or table—for numerous

other still-life painters, including three food specialists in the Jones Collection: Severin Roesen, George Forster, and John Francis. Food remained the primary subject of still-life painters until the midcentury—and the tradition continued well beyond.

No still-life painter communicated the era's sense of abundance and optimism more overtly than Roesen, whose *Still Life with Fruit and Wine* bursts with produce (cat. no. 25). Roesen immigrated to New York from Germany in late 1847 and moved to Pennsylvania in 1857. His paintings, with their Baroque profusion, are meant to suggest the prosperity of their owners, and they

FIG. 10. Raphaelle Peale (American, 1774–1825), *Still Life—Strawberries, Nuts, &c.*, 1822. Oil on wood panel, 16 3/16 × 22 3/4 in.

Art Institute of Chicago, Gift of Jamee J. and Marshall Field, 1991.100. Photo credit: The Art Institute of Chicago / Art Resource, NY.

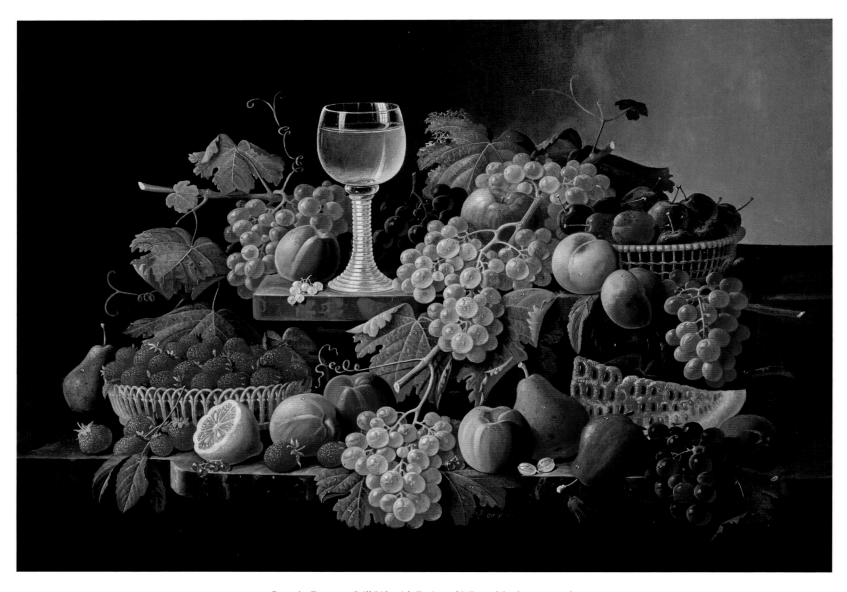

Severin Roesen, *Still Life with Fruit and Wine*, 1862 (cat. no. 25).

John Francis, *Still Life with Currants*, circa 1870 (cat. no. 12).

are certainly indebted to European prototypes. But their clarity, denial of the artist's hand, and apparent sense of confidence in the future is more decidedly American. Roesen's *Still Life with Fruit and Wine* centers on a full and beautifully rendered glass of white wine, itself indicative of abundance. Three varietals of grapes encircle this glass, along with peaches, pears, currants, an apple, a slice of watermelon, and half a lemon. In addition, a wicker basket of plums and a porcelain basket of strawberries both overflow with fruit. This is no memento mori intended to remind viewers of their mortality; it suggests just

the opposite. Some of the fruit is underripe, an indication of youth and an acknowledgment that there is more where this came from. Nary a single piece is spoiled; indeed, hardly a blemish appears. Only the grape leaves, which curl or are a bit eaten at the edges, provide hints of age. As with other of Roesen's still lifes, this painting is, as Gerdts describes, "a visual expression of midcentury optimism, of God's bounty upon the New World as a new Eden."[68]

The same is essentially true of John Francis's *Still Life with Currants* (cat. no. 12), which is not as bounteous as Roesen's, given that it features

only one type of fruit, though the currants are portrayed with exquisite perfection. Born in Philadelphia, Francis became best known for his still lifes of food, including not only fruit, as here, but also cheese, crackers, and desserts, the edibles generally presented with accompanying serving items. In the Jones painting, the subject is kept simple. Many currants cling to the branch; others roll across the table or spill out of a simple white bowl in the background. The currants are fresh, the leaves hardly wilted. Only one yellow leaf suggests the passage of time.

George Forster's 1869 *Still Life with Fruit and Nest* (cat. no. 11) is also lusciously rife, with grapes, currants, strawberries, plums, and even a bird's nest filled with eggs, the latter a favorite element of the American Pre-Raphaelite painters. Like Roesen, Forster was German, but he did not immigrate to New York until 1865, the end of the Civil War. The Jones painting, which was rendered four years later, suggests a loss of innocence. One of the plums is obviously split; the board on which the fruit rests contains knotholes; and the sky in the background is ominous. Most obviously, one of the eggs has fallen out of its nest and cracked in half, a conceit easy to read as a metaphor for the divided nation.

Slightly later in date are still lifes by William Michael Harnett and his Cincinnati-born counterpart Claude Raguet Hirst (cat. nos. 14, 17), the latter having truncated her name from Claudine to create parity with male colleagues. Both artists, along with other still-life specialists of the era, elevated the already precise approach of their predecessors into a dazzling, trompe-l'oeil technique. Many also changed the focus of their subject matter from objects made by nature to ones made by people, supplanting God's handiwork with humanity's—an indication, perhaps, of the greater industrialization and urbanization of the late nineteenth century. These two still lifes differ, too, in that they would not have been associated with the kitchen or dining room as food subjects were, spaces more traditionally associated with women. These are smoking subjects, or "bachelor" still lifes, as they are sometimes called, suited to traditionally masculine domains. Both paintings include elements that the artists painted best. The Harnett features a stoneware jug, pipe, tobacco, matches, and a newspaper. Hirst's also depicts a pipe, tobacco, and matches, as well as pince-nez glasses, a jar, and a candle. Additionally, she includes a book, one of her favorite pictorial devices, which can sometimes offer clues into the interpretation of her paintings.

RECESSES OF THE HEART

Even after American optimism had diminished due to industrialization, the Civil War, and rapid social changes, many artists continued to represent the country as pastoral and bucolic. Regardless of whether they were painted before or after the Civil War, the landscapes in the Jones Collection are all rural, though each contains a human element as well—either overt or implied. Most portray an America in the early stages of domestication, the scenes remaining free of industry, overt development, and other potentially negative consequences of modern life.

Landscape paintings had been done this way since Cole, who himself preferred to depict uncultivated nature, which he felt even in the first half of the nineteenth century was rapidly being

FACING: George Forster, *Still Life with Fruit and Nest*, 1869 (cat. no. 11).

lost. Because Cole's paintings often presented the landscape as it was before succumbing to "progress," they appealed, as art historian Alan Wallach described, to his patrons' "growing capacity for nostalgia."[69] Cole and other painters saw their art, at least in part, as preservationist. In his "Essay on American Scenery," Cole stated that "the wilderness is YET a fitting place to speak of God," the emphasis on "yet" indicating that this was not likely to be the case for long.[70] He worried about humanity's effect on the environment, which included not only the rapid expansion of cities and the growth of industry but also the steady "iron tramp" of the railroad that threatened to crush the "bright and tender flowers of the imagination."[71] He expressed chagrin at the speed with which mankind was exterminating nature's beauty, observing, "The ravages of the axe are daily increasing—the most noble scenes are made desolate, and oftentimes with a wantonness and barbarism scarcely credible in a civilized nation." He wrote with emotion:

> And to this cultivated state our western
> world is fast approaching; but nature is still
> predominant, and there are those who regret
> that with the improvements of cultivation
> the sublimity of the wilderness should pass
> away: for those scenes of solitude from
> which the hand of nature has never been
> lifted, affect the mind with a more deep
> toned emotion than aught which the hand
> of man has touched.[72]

Cole was ahead of his time, which accounts, in part, for the longevity of his ideas in the realm of art. George Perkins Marsh, for instance, did not publish his influential *Man and Nature* until 1864, the book helping to create widespread awareness of humanity's impact on the environment. And it was not until the late nineteenth century that there began to be a broad turnabout in the popular conception of nature—from something to be developed and exploited to that which should be preserved and protected.

Durand also believed in the reformative power of art. As urbanization removed many citizens from rural life, art patrons looked to views of untrammeled wilderness and country subjects as a comforting antidote to rapid social change and life in the city. In 1857, the *Cosmopolitan Art Journal* reported, "Craving for the country is fast becoming a passion; and if centralization in cities is a fact, it is also true that the aggregated tens of thousands seek every opportunity for 'breathing country air,' if not for 'holding converse with Nature.' . . . Art has its most appreciative patrons among the country-lovers."[73] Durand called landscape paintings "an oasis in the desert," considering them, as did other artists of the era, as a place to "rest and reflect." They also, Durand admitted, summoned nostalgia, offering viewers the opportunity to "trace their first enjoyment of existence, in childhood and youth . . . to the country, to some pleasant landscape scenery":

> In spite of the discordant clamor and con-
> flict of the crowded city, the true landscape
> becomes a thing of more than outward
> beauty, or piece of furniture.
>
> It becomes companionable, holding
> silent converse with the feelings, playful or
> pensive—and, at times, touching a chord
> that vibrates to the inmost recesses of the

heart, yet with no unhealthy excitement, but soothing and strengthening to his best faculties. Suppose such an one, on his return home, after the completion of his daily task of drudgery—his dinner partaken, and himself disposed of in his favorite armchair, with one or more faithful landscapes before him, and making no greater effort than to look into the picture instead of on it, so as to perceive what it represents; in proportion as it is true and faithful, many a fair vision of forgotten days will animate the canvas, and lead him through the scene: pleasant reminiscences and grateful emotions will spring up at every step, and care and anxiety will retire far behind him.[74]

Paintings in the Jones Collection are similarly "companionable," being romantic, idealized, and picturesque. Not surprisingly, they were acquired by their present owners for reasons much like those of their original purchasers. Many of the works depict America as a garden. Foliage is verdant, quiet streams meander among framing trees, mountains loom in the distance, ducks swim, and cattle graze. When people are included, they are shown in harmony with nature, exemplifying the pastoral ideal.

FREEDOM'S OFFSPRING

Most landscape artists in the first half of the nineteenth century believed that humanity, and evidence of humanity, could acceptably appear in a landscape as long as they increased the communicative power of the natural scene and did not dominate the painting's message. As the century wore on, this became increasingly true,

as both artists and the public became ever more interested in domesticated landscapes. Even if people themselves were not included, houses and buildings, cultivated ground, livestock, fences, roads, paths, and bridges could all attest to their presence. Artist George Inness, who began his career working in the Hudson River School style but became better known for his Barbizon-style paintings, came to find "civilized" landscapes worthier of his brush than that which was "savage and untamed." "It is more significant," he explained in an 1878 interview. "Every act of man, every thing of labor, effort, suffering, want, anxiety, necessity, love, marks itself wherever it has been."[75]

This practice remained less true in the American West—at least initially—where artists continued to focus on sublime depictions of untamed nature, the landscape itself being less explored, less developed, and, arguably, more sublime. Albert Bierstadt, who is represented in the Jones Collection by *A Golden Summer Day Near Oakland* (circa 1873; cat. no. 1), was one of the artists who worked in the West, along with Thomas Hill, Thomas Moran, and others. Best known for portraying nature's most magnificent Western settings, Bierstadt, like his colleagues, also turned to quieter scenes of trees, lakes, hillsides, and meadows—often with people. His Oakland scene portrays California as a pastoral paradise, within which a man and two women—surely meant to depict the artist, his wife, and sister-in-law—enjoy a picnic.[76] This is fertile ground: men harvest hay; an orchard promises a crop.

The human presence in the Bierstadt painting is a critical component of the whole, which is the case for many of the works in the Jones

Eastman Johnson, *At the Maple Sugar Camp*, circa 1860s (cat. no. 19).

Collection. People are shown strolling, contemplating nature, hunting, fishing, and boating, the figures adding narrative, offering a sense of scale, and providing a sense of completeness. Several artists included America's indigenous people in their landscapes, such as in Jasper Cropsey's 1872 autumnal landscape *Eagle Cliff, New Hampshire* (cat. no. 7), in which American Indians appear with canoes. Indians are also featured in Scottish-born painter William Thompson "Russell" Smith's 1867 painting *Silver Lake with Indian Teepee* (cat. no. 26), the teepee likely added for picturesque effect, since it is doubtful that Smith saw one in Pennsylvania, Virginia, or any of the New England states where he generally worked.

A number of paintings in the Jones Collection blur the boundaries between landscape and genre painting; others depict scenes of everyday American life for its own sake. As with landscapes, genre paintings had the potential to moralize, induce piety or patriotism, and, to an even greater degree, evoke nostalgia for simpler times. Following the Civil War, genre scenes also served to bring the country together by reminding viewers of mutual experiences

and acknowledging the nation's collective sense of loss. As Cole long before acknowledged, "It is generally admitted that the liberal arts tend to soften our manners; but they do more—they carry with them the power to mend our hearts."[77]

Genre painting gained in popularity from the 1830s into the 1840s and 1850s, when many scenes of American daily life were disseminated as engravings by art unions, which not only offered subscribers of limited means the opportunity to have a print on their walls but also gave them a chance to win an original painting of their own through a lottery system. The firm of Currier & Ives, "Publishers of Cheap and Popular Prints," went a step further, disseminating thousands of hand-colored lithographs both pre– and post–Civil War that depicted the gamut of American life. The scenes were rendered by—and after the work of—many of the era's celebrated artists.

Eastman Johnson was one of these artists. Best known as a painter, he rendered *At the Maple Sugar Camp* (cat. no. 19), which shows two boys taking a break from their work, the tools of their trade set aside. It is one of two genre paintings in the Jones Collection that focus on young children. The other is Thomas Hicks's *Frugal Meal* (cat. no. 16), featuring a girl with

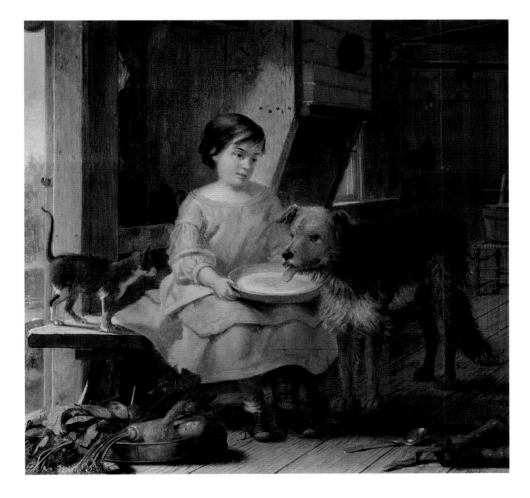

Thomas Hicks,
Frugal Meal, 1850
(cat. no. 16).

Thomas Worthington Whittredge, *Barn Interior*, circa 1852 (cat. no. 27).

a dog and a cat, both eager to share her lunch. Thomas Worthington Whittredge's *Barn Interior* (cat. no. 27) includes an older girl or young woman, who quietly knits while tending goats, the nearby brooms and spinning wheel sitting idle. The artist surely created the scene while living in Düsseldorf, Germany, as the painting relates closely to the artist's *Interior of a Westphalian Cottage* (1852; fig. 11), in the collection of the Smithsonian American Art Museum. The Smithsonian work is larger but very similar, though it lacks goats. The inclusion of the animals in the Jones painting indicates that the structure is a barn rather than a cottage.

Jervis McEntee's *Sitting by the Fire* (cat. no. 21) also features a young woman, her pensive expression and costume suggesting she has lost a loved one in the Civil War—probably the soldier in the framed portrait by the fire. The date of the painting is 1865, the year the war ended, and the woman wears mourning black, her matte-surface dress lacking any ornamentation other than lace at the collar and a lavender ribbon, both indicative of second-stage mourning.[78] The setting—really a large still life—appears more animated than the woman herself. The mantel is adorned with a green, tasseled cloth topped by bric-a-brac, candlesticks, and a geranium. Artwork and side chairs flank the mantel, and above it hang a mirror and an oval landscape painting. Andirons and other fireplace equipment sparkle in the glow of a gently burning fire.

John Frederick Kensett's *School's Out* (cat. no. 20) blurs the boundaries between genre and landscape painting, as children play outside a distant one-room schoolhouse in a landscape that remains the primary focus. Enoch Wood Perry's

FIG. 11. Thomas Worthington Whittredge (American, 1820–1910), *Interior of a Westphalian Cottage*, 1852. Oil on canvas, 27⅝ × 19⅞ in. Smithsonian American Art Museum, L. E. Katzenbach Fund, 1967.142.2.

Ice Skating Party (cat. no. 22) is also a landscape with people, this one more human-centered and surely inspired by European prototypes (the figures are reminiscent of seventeenth-century Dutch paintings of the same subject). These paintings and others like them manifest an American "peace, security, and happiness" that

Cole called "freedom's offspring." He wrote, "On the margin of that gentle river the village girls may rample . . . and the glad school-boy, with hook and line, pass his bright holiday—those neat dwellings, unpretending to magnificence, are the abodes of plenty, virtue, and refinement. And in looking over the yet uncultivated scene, the mind's eye may see far into futurity."[79]

FAITHFUL AND BEAUTIFUL

Most of the painters whose works make up the Jones Collection arrived at their mature styles and subject matter during a period when Cole's idea of "futurity" still seemed possible. But Charles Darwin's 1859 book on evolution, *On the Origin of Species*, and then the Civil War, conspired to shake American optimism and confidence.[80] At the same time, the idea that art needed to communicate moral, educational, and spiritual messages that could serve the broader public good began to give way to a belief that art should put the artists' individuality and emotions first.

Photography, which captured the landscape with greater verisimilitude than painters ever could, was in part responsible for the evolution in style. World fairs, notably the 1867 Exposition Universelle in Paris and the 1876 Centennial Exposition in Philadelphia, also served to highlight American conservatism, as did the importation of new, more painterly approaches from France, which prompted many artists to leave behind their exacting, outward views of nature in favor of more deeply personal scenes concerned with the physicality of the artworks themselves. At the same time, the tastes of American art patrons became more cosmopolitan, with many picture buyers now finding precisely

painted American subject matter provincial. Their attentions turned instead to the work of the old masters, contemporary French Barbizon painters and academicians, and society portraitists. Thousands of American art students sought training in Munich and, especially, Paris, which had practically become a prerequisite for artistic success at home.[81]

In 1879, the painter and critic S. G. W. Benjamin described what he felt were the inadequacies of an increasingly outdated Hudson River School style of painting:

> If there has been a fault in this school of American landscape art, it has been, perhaps, in endeavoring to get too much in a picture, in trying to be too literal; so that the great attention given to the details had excited wonder rather than stimulated the imagination, and had marred the impression of general effect which should be the chief idea in a work of art.[82]

Within this context, the beautiful stillness, meticulous rendering, and keenly observed detail that had once made paintings like those in the Jones Collection so popular—even awe-inspiring—now seemed documentary and pedantic in the context of less literal, dynamic, and painterly works. Though various still-life painters continued to utilize a trompe-l'oeil approach, landscape painters either adapted to new trends or found themselves brushed aside. "They are faithful and beautiful," wrote G. W. Sheldon, author of *American Painters* (1879), about Frederic Church's Hudson River School landscapes, "but they are not so rich as they might be in the poetry, the aroma, of art."[83]

In hindsight, we know it is possible to appreciate paintings that are "faithful and beautiful" as well as works that are rich in the "aroma of art." Also clear is that the importance of works like those in the Jones Collection runs deeper than technical proficiency and surface polish. As is so often the case, a younger, emerging group of artists and critics did not accord due credit to the generation prior. Though the elder artists were adroit at imitation, and their works certainly appear true to their source, the artists aimed to select and recombine the best of American nature and its bounty to communicate ideas broader than art itself. Many of them envisioned the young United States with ideal pastoralism, suggesting the benefits of a life led close to nature. Others communicated a spirit of American optimism, of transcendental wonderment in nature, of national abundance, and of nostalgia for ways of life that, even as the scenes were being painted, seemed already to be passing. In addition, the paintings emblematize a time when United States citizens sought to define what it meant to be American, and when the nation's patrons—much like the Joneses—most deeply appreciated art drawn from native soil.

NOTES

1. Thomas Cole, "Essay on American Scenery," *American Monthly Magazine* 1 (January 1836): 12.

2. Clement Eaton, *Henry Clay and the Art of American Politics*, ed. Oscar Handlin (Boston and Toronto: Little, Brown and Company, 1957), 152.

3. Robert V. Remini, *Henry Clay: Statesman for the Union* (New York, London: W. W. Norton & Co., 1991), 79.

4. Ibid., 12–13.

5. Congressman Josiah Quincy of Massachusetts stated of Clay, "Such was the man whose influence and power more than that of any other produced the War of 1812." Edmund Quincy, *Life of Josiah Quincy of Massachusetts* (Boston: Ticknor and Fields, 1867), 255.

6. Henry Clay, December 1811, quoted in Remini, *Henry Clay*, 77.

7. Henry Clay, "The American System," February 2, 3, and 6, 1832, delivered in the Senate, in *The Senate, 1789–1989; Classic Speeches, 1830–1993*, vol. 3, ed. Wendy Wolff (Washington, D.C.: U.S. Government Printing Office), 89.

8. Ibid., 83.

9. De Witt Clinton, *Discourse, Delivered Before the American Academy of the Arts* (New York: T. & W. Mercein, 1816), 16.

10. James Kirke Paulding, quoted in Richard Ruland, ed., *The Native Muse: Theories of American Literature*, vol. 1 (New York: E. P. Dutton, 1976), 136.

11. December 26, 1805, Academy Charter, Pennsylvania Academy of the Fine Arts website, www.pafa.org.

12. John L. O'Sullivan, "The Great Nation of Futurity," *The United States Magazine and Democratic Review* 6 (November 1839): 428–429.

13. "The Neglected American Plants," *The Horticulturist, and Journal of Rural Art and Rural Taste* 6 (May 1, 1851): 201–203.

14. Clay, "The American System," 102.

15. Cole, "Essay on American Scenery," 1.

16. Ralph Waldo Emerson, "The American Scholar: An Oration," delivered before the Phi Beta Kappa Society at Cambridge, August 31, 1837, quoted in *The Collected Works of Ralph Waldo Emerson*, vol. 1, introduction and notes by Robert E. Spiller (Cambridge, MA: The Belknap Press of Harvard University Press, 1971), 52.

17. A. B. Durand, "Letters on Landscape Painting. Letter II," *The Crayon* 1 (January 17, 1855): 34–35.

18. From a July 4, 1787, oration delivered at Petersburgh, Virginia, in commemoration of the American independence, quoted in Neil Harris, *The Artist in American Society: The Formative Years, 1790–1860* (New York: George Braziller, 1966), 29.

19. Harris, *The Artist in American Society*, 35.

20. Ibid., 33, 36.

21. Thomas Jefferson, "Hints to Americans Traveling in Europe," quoted in Douglas L. Wilson and Lucia Stanton,

eds., *Jefferson Abroad* (New York: The Modern Library, 1999), 251.

22. John Trumbull, quoted in A. B. Durand, "Letters on Landscape Painting. Letter IV," *The Crayon* 1 (February 14, 1855): 97.

23. Alexis de Tocqueville, *Democracy in America*, vol. 2, ed. Phillips Bradley, trans. Henry Reeve (New York: Alfred A. Knopf, 1945; reprint ed., New York: Vintage Books, 1990), 136.

24. Daniel Walker Howe, "Victorian Culture in America," in *Victorian America*, ed. D. W. Howe (Philadelphia: University of Pennsylvania Press, 1975), 9.

25. De Tocqueville, *Democracy in America*, vol. 2, 134.

26. Alan Wallach, "Thomas Cole and the Aristocracy," *Arts Magazine* 56 (November 1981): 98.

27. Author's emphasis. Cole, "Essay on American Scenery," 3; and Cole's unpublished essay "Influence of the Plastic Arts" (1840), quoted in Kenneth James LaBudde, "The Mind of Thomas Cole" (Ph.D. diss., University of Minnesota, 1954), 161.

28. *The Crayon* 5 (June 1858), quoted in John K. Howat, "A Climate for Landscape Painters," in The Metropolitan Museum of Art, *American Paradise: The World of the Hudson River School*, introduction by John K. Howat (New York: The Metropolitan Museum of Art, 1987), 64.

29. Cole, "Essay on American Scenery," 6.

30. Ibid., 9.

31. O'Sullivan, "The Great Nation of Futurity," 427.

32. Cole, "Essay on American Scenery," 11.

33. O'Sullivan, "The Great Nation of Futurity," 430.

34. According to Kevin J. Avery, the name may have been supplied by critic Clarence Cook of the *New York Tribune* or landscape painter Homer D. Martin. Kevin J. Avery, "A Historiography of the Hudson River School," in *American Paradise*, 3–4.

35. *The Knickerbocker* 2 (July 1833), quoted in Howat, "A Climate for Landscape Painters," 50.

36. *New York Evening Post*, April 23, 1847, quoted in Oswaldo Rodriguez Roque, "The Exaltation of American Landscape Painting," in *American Paradise*, 35–36.

37. Emerson, "Nature," in *The Collected Works of Ralph Waldo Emerson*, vol. 1, 17.

38. See Matthew Baigell, *Thomas Cole* (New York: Watson-Guptill Publications, 1985; reprint, 1998), 25–26.

39. Cole, "Essay on American Scenery," 3.

40. Durand, "Letters on Landscape Painting. Letter IV," 98.

41. A. B. Durand, "Letters on Landscape Painting. Letter I," *The Crayon* 1 (January 3, 1855): 2; and A. B. Durand, "Letters on Landscape Painting. No. VIII," *The Crayon* 1 (June 6, 1855): 354.

42. Durand, "Letters on Landscape Painting. Letter II," 34.

43. See Avery, "A Historiography of the Hudson River School," 14.

44. Thomas Cole to Robert Gilmor, December 25, 1826, reprinted in Howard S. Merritt, ed., "Appendix I: Correspondence Between Thomas Cole and Robert Gilmor, Jr.," in Baltimore Museum of Art, *Annual II: Studies on Thomas Cole, an American Romanticist* (Baltimore, MD: Baltimore Museum of Art, 1967), 47.

45. This statement seems incongruous given Ruskin's defense of the Romantic English landscape painter Joseph Turner, whom, despite the expressive nature of his paintings, Ruskin saw as complying with nature's realities rather than the rules of pictorial convention. John Ruskin, "Preface to the Second Edition of *Modern Painters* (1844)," in Joshua C. Taylor, *Nineteenth-Century Theories of Art* (Berkeley: University of California Press, 1987), 289.

46. Ibid., 290.

47. Ibid., 295.

48. Ibid., 294, 296.

49. John Ruskin, M.A., *Modern Painters*, vol. 5 (New York: John Wiley, 1860), 38.

50. Durand, "Letters on Landscape Painting. Letter IV," 98.

51. Durand, "Letters on Landscape Painting. Letter I," 2.

52. A. B. Durand, "Letters on Landscape Painting. Letter III," *The Crayon* 1 (January 31, 1855): 66; Durand, "Letters on Landscape Painting. Letter I," 2.

53. A. B. Durand, "Letters on Landscape Painting. No. V," *The Crayon* 1 (March 7, 1855): 146.

54. Of the landscape artists in the generation younger than Cole, Matthew Baigell writes, "Few were interested in weighting landscape painting with as much religious and moral baggage as Cole wanted it to carry. Less intellectual, they were less concerned with the fallibility of man and his

institutions as well as less interested in extracting profound meaning from seasonal changes or even from the existence of nature itself. They were content to celebrate the landscape for less complex religious meanings and for its sheer visual splendor." Baigell, *Thomas Cole*, 26.

55. A. B. Durand, "Letters on Landscape Painting. No. VII," *The Crayon* 1 (May 2, 1855): 275.

56. Durand, "Letters on Landscape Painting. No. VIII," 354.

57. A. B. Durand, "Letters on Landscape Painting. No. IX," *The Crayon* 2 (July 11, 1855): 16.

58. Durand, "Letters on Landscape Painting. No. VIII," 354.

59. Ibid., 355.

60. [Franklin B. Dexter], "Modern Painters," *North American Review* 66 (January 1848): 113.

61. Andrew Jackson Downing, "A Few Hints in Landscape Gardening," *The Horticulturist, and Journal of Rural Art and Rural Taste* 6 (November 1, 1851): 491. See also Judith K. Major, "The Type of All True Art in Landscape Gardening," in Judith K. Major, *To Live in the New World: A. J. Downing and American Landscape Gardening* (Cambridge, MA: MIT Press, 1997), 154–157.

62. Durand, "Letters on Landscape Painting. No. VIII," 354.

63. Durand, "Letters on Landscape Painting. No. V," 146.

64. Durand, "Letters on Landscape Painting. No. VII," 275.

65. William H. Gerdts, *Two Centuries of American Still-Life Painting: The Frank and Michelle Hevrdejs Collection* (Houston: Museum of Fine Arts, Houston, 2016), 38.

66. See William H. Gerdts, *Painters of the Humble Truth: Masterpieces of American Still Life, 1801–1939* (Columbia: University of Missouri Press, 1981), 22.

67. Emphasis per original. Daniel Fanshaw, "The Exhibition of the National Academy of Design, 1827," *The United States Review and Literary Gazette* 2 (July 1827): 258.

68. Gerdts, *Two Centuries of American Still-Life Painting*, 36.

69. Wallach writes, "The America Cole portrayed in these early paintings was rarely the America of his own time. Rather it was 'real' landscape cast in the past tense: the land restored to its pristine appearance." "Thomas Cole and the Aristocracy," 98.

70. Cole, "Essay on American Scenery," 2.

71. Ibid., 3.

72. Ibid., 12, 5.

73. *Cosmopolitan Art Journal* 1 (September 1857), quoted in Howat, "A Climate for Landscape Painters," 57.

74. Durand, "Letters on Landscape Painting. Letter IV," 98.

75. [George Inness], "A Painter on Painting," *Harper's New Monthly Magazine* 56 (February 1878): 461.

76. Historian Alfred C. Harrison Jr. identifies the figures in the painting as Bierstadt, his wife, Rosalie, and Rosalie's sister Esther (reading). Alfred C. Harrison Jr., "California Painting of the Nineteenth Century" (unpublished manuscript, 2016), 62.

77. Cole, "Essay on American Scenery," 1.

78. I thank costume expert Melissa Leventon of Curatrix Group for confirming that the woman is wearing mourning attire.

79. Cole, "Essay on American Scenery," 12.

80. Art historian Oswaldo Rodriguez Roque writes, "The ideas that had been at the core of the entire Hudson River School tradition lost their immediacy as they confronted, first, a new Darwinian science that made it difficult to see the hand of the Creator operating behind every leaf and rock and, second, a new mood in the country, which after the horrors of the Civil War could no longer perceive of itself as the new Eden." Oswaldo Rodriguez Roque, "The Exaltation of American Landscape Painting," in *American Paradise*, 48.

81. See William H. Gerdts, *Two Centuries of American Still-Life Painting*, 20–21.

82. S[amuel] G[reene] W[heeler] Benjamin, *Our American Artists* (Boston: D. Lothrop and Co., 1879), quoted in Doreen Bolger Burke and Catherine Hoover Voorsanger, "The Hudson River School in Eclipse," in *American Paradise*, 73.

83. G[eorge] W[illiam] Sheldon, *American Painters: With Eighty-three Examples of Their Work Engraved on Wood* (New York: D. Appleton and Co., 1879), 13.

CATALOGUE OF THE COLLECTION

1 *[see also page xi]*

ALBERT BIERSTADT

American, b. Germany, 1830–1902

A Golden Summer Day Near Oakland, circa 1873

Oil on paper laid down on masonite, 16 ⁹⁄₁₆ × 22¼ in.

On verso: "Near Oakland / California"

Albert Bierstadt is celebrated for his vast frontier landscapes of the American West. Originally from Solingen, near Düsseldorf, he immigrated to the United States when he was two years old and was raised in New Bedford, Massachusetts. He returned to Germany in 1854 to study art at the Düsseldorf Art Academy, where he shared a studio with Thomas Worthington Whittredge. Back in the United States by 1857, Bierstadt resettled in New Bedford and painted the countryside near his home and the White Mountains region of New Hampshire.

One of the most significant turning points of his career occurred in 1859, when Bierstadt journeyed west to the Nebraska Territory and Rocky Mountains with Frederick Lander and his land survey team. After returning to the East Coast in 1860, Bierstadt rented a studio and living quarters in the famed Tenth Street Studio Building, alongside the most famous artists of his time, such as Whittredge, Sanford Robinson Gifford, and Frederic Edwin Church. In May 1863, he departed on a second western trip alongside explorer and journalist Fitz Hugh Ludlow. By August they had reached Yosemite Valley: the studies from this sojourn were the sources for many of his large-scale paintings for exhibition throughout the 1860s. He received great publicity for these depictions of Yosemite Valley, prompting the artist to make another extended Northern California visit from 1871 to 1873.

This time Bierstadt and his wife, Rosalie Osborne, came west on the new transcontinental railroad and were based in San Francisco.

———

Rosalie (Osborne) was first married to Ludlow, with whom Bierstadt ventured west in 1863. She divorced him in May 1866 and married Bierstadt that same year. While in San Francisco, the Bierstadts traveled throughout Northern California. Founded less than twenty years before, Oakland by 1870 was a major railroad depot and the terminus of the transcontinental railroad. Bierstadt depicts a bucolic scene outside the city, with horses and workers cutting hay.

The painting is a charming memento for the artist and his family—a souvenir of their time in California. Thin, bearded, and dressed in a brown two-tone suit with a blue tie and white shirt, the artist sprawls on his stomach on a red picnic blanket. He looks up endearingly at his wife. Rosalie, dressed in a white dress and red jacket with a matching cap, sits on a folding stool and leans forward to engage in conversation with her husband. Seated behind the painter is his sister-in-law, Esther, a frequent traveling companion of Rosalie. She reads in the shade of an oak tree, wearing a blue dress and straw hat in a careful counterbalance to the warm color of her

sister's dress. The shaded, grassy hillside on which they rest contrasts with the yellow fields occupying the middle ground. Another couple sits halfway in between, and farmers—with livestock and rakes in hand—work in the open field. A grove of trees casts rhythmic shadows on the mauve ground at center. A series of mountains, diffuse in color, rise in the distance. Although the figures occupy the foreground, they are fairly small within a composition that emphasizes the terrain and golden California sunlight, the latter accorded the central role in the landscape.

L.S.

PROVENANCE: Estate of the artist; Elliott Bloom (New York, New York), acquired from above; Alexander Gallery (New York, New York), acquired from above, 2003; Arader Galleries (San Francisco, California), acquired from above, 2005; Private collection (Tiburon, California), acquired from above; Questroyal Fine Art, LLC (New York, New York), acquired from above, 2012; Private collection (Boston, Massachusetts), acquired from above, 2012.

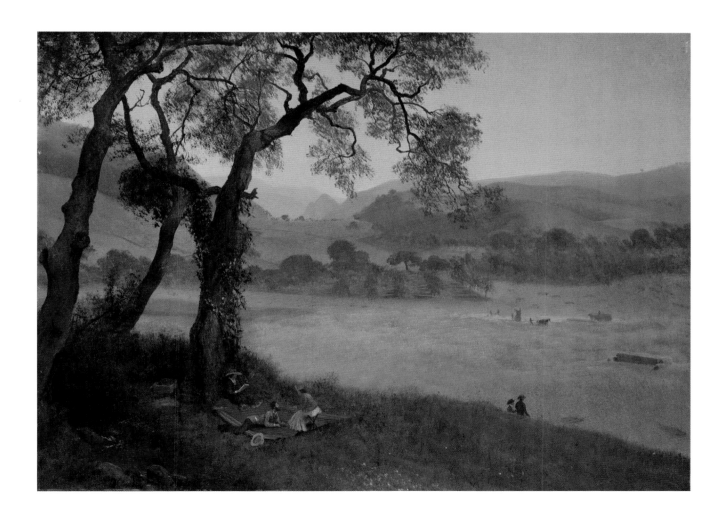

2

RALPH ALBERT BLAKELOCK

American, 1847–1919

Landscape, circa 1868

Oil on canvas, 19⅞ × 36 in.

Signed "R. A. Blakelock" at lower left

Born in New York City, Ralph Albert Blakelock began his studies in medicine at the Free Academy of New York City (presently known as City College) in 1864 but left after two years. At age nineteen, he joined the Hudson River School painters at the National

Academy of Design, where he exhibited annually until 1880. Between 1869 and 1872, Blakelock ventured out west on his own and lived among Native American tribes. Unlike his contemporaries who journeyed with companions or on sponsored expeditions, Blakelock

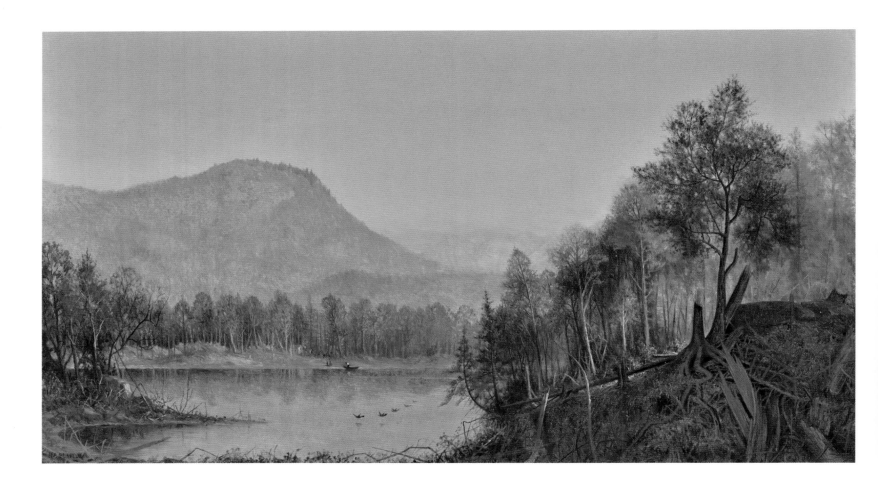

preferred to travel independently. Upon his return to New York, he rented a studio and registered himself as an artist in the city directory.

Blakelock was a largely self-taught artist, continuously improvising and developing his methods and style. Although his mature work is more subjective and sublime, particularly his poetic moonlit landscapes, he emulated the first generation of Hudson River School painters early in his career.

———•———

Landscape reflects the influence of the Hudson River School. Stylistically, this painting is comparable to other naturalistic early views by Blakelock; it most closely resembles his earliest signed and dated work, *Sunrise* (North Carolina Museum of Art). Based on the similar composition and scale, as well as his ever-changing signature[1]—which appears in tall, block letters at the lower left—*Landscape* can be dated to around 1868. Therefore, Blakelock likely painted it at the same time as *Sunrise*, if not at the same place. To the Hudson River School tradition, Blakelock added an emotional tone, revealing what scholars have characterized as "a sense of loneliness and stillness, of the desolation of the wilderness with its debris of dead trees and branches, a pervading melancholy."[2]

The subject of the work is one painted by many of Blakelock's contemporaries, the "home in the wilderness," but he gives it an unusually poetic atmosphere. In the right foreground, a densely woven intersection of angular twigs, trunks, branches, and

roots forms an impenetrable space. Yet light emanates from within the forest—an unusual and mysterious source of illumination, given the daylight scene. Across the lake, a man in a white shirt docks his rowboat at the shore. He is greeted by two figures, presumably his wife and child; their house is nestled among the trees just beyond them. A winding dirt path from the shoreline to their home and the cleared trees nearby are the only marks of the land altered by humans. The rest of the landscape appears unchanged and untamed, with a life of its own. L.S.

PROVENANCE: George F. McMurray Collection (Glendale, California) on loan to Trinity College (Hartford, Connecticut), 1969; Questroyal Fine Art, LLC (New York, New York).

LITERATURE: David Gebhard and Phyllis Stuurman, *The Enigma of Ralph A. Blakelock, 1847–1919* (Santa Barbara: The Regents, University of California, 1969), cat. no. 29; Mark D. Mitchell, "Radical Color: Blakelock in Context," in *The Unknown Blakelock*, ed. Karen O. Janovy (Lincoln, NE: Sheldon Memorial Art Gallery), fig. 1; Questroyal Fine Art, LLC, *Ralph Albert Blakelock: The Great Mad Genius* (New York: Questroyal Fine Art, LLC, 2005), illus. 40; Questroyal Fine Art, LLC, *A Young America: Wild and Free, Paintings of the Hudson River School* (New York: Questroyal Fine Art, LLC, 2006).

NOTES
1. Norman Geske, *Beyond Madness: The Art of Ralph Blakelock, 1847–1919* (Lincoln: University of Nebraska Press, 2007), 98.
2. Lloyd Goodrich, *Ralph Albert Blakelock Centenary Exhibition, In Celebration of the Centennial of The City College of New York* (New York: Whitney Museum of American Art, 1947), 11.

3

WILLIAM BRADFORD
American, 1823–1892
Coast of Labrador, 1866
Oil on canvas, 20 × 30 in.
Signed and dated "Wᵐ Bradford 66" at lower right

Born to Quakers in the coastal town of Fairhaven, Massachusetts, William Bradford as a youth assisted his father in running the family's drygoods store. By 1855, he had opened his first studio, painting ship portraits, a subject appropriate to his upbringing in a whaling community. In 1860, he moved to New York City, settling in the prestigious Tenth Street Studio Building, which counted Albert Bierstadt among its tenants.

Throughout his life, Bradford traveled extensively. Sketches and photographs from his expeditions to Labrador and the Arctic during the 1860s provided stimulus for much of his mature work. He later recalled, "Why, my photographs have saved me eight or ten voyages to the Arctic regions, and now I gather my inspirations from my photographic subjects."[1] In 1872, Bradford spent a year in London, where he presented lectures on the Arctic illustrated with photographs from his expeditions. While abroad, he completed *The Panther off the Coast of Greenland under the Midnight Sun* (1873), a commission from Queen Victoria. Bradford returned to the United States, lectured frequently, explored the West, painted scenes of Yosemite, and periodically lived in San Francisco. Following his Arctic travels in the 1860s, he took up short-term residencies in San Francisco's Palace Hotel during the 1870s. The *San Francisco Daily Evening Bulletin* reported, "All lovers of art, and especially of the Arctic scenery, find the artist at home in his particular line of work. . . . Bradford as an artist has

taken possession of the Arctic region. The country all up around the North Pole belongs to him by right of artistic possession."[2] Bradford died in New York City.

———•———

The large geological formation rising from the mist in *Coast of Labrador* is likely "Devil's Dining Table," a massive column of basalt near Henley Harbor on the southeast coast of Labrador, Canada. Due in part to this distinctive feature, Henley Harbor became a popular destination for landscape painters.[3] *Coast of Labrador* depicts familiar artistic territory for

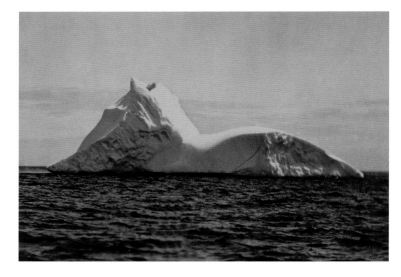

William Bradford (American, 1823–1892), *The Arctic Regions: Illustrated with Photographs Taken on an Art Expedition to Greenland*, plate 8.
Courtesy of the New Bedford Whaling Museum.

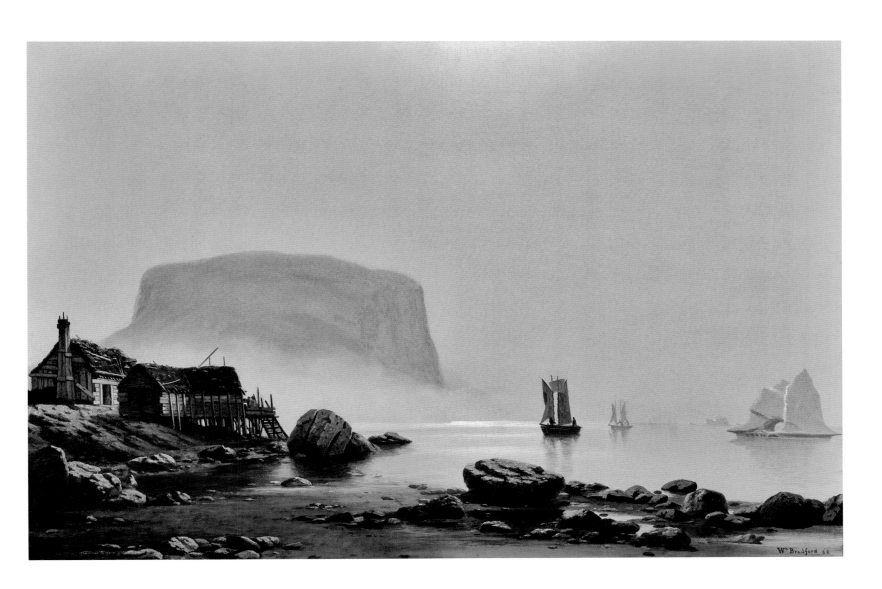

Bradford, who traveled to Labrador several times between 1854 and 1857 before embarking on his better-known Arctic voyages. Unlike many of Bradford's northern landscapes, the scene shows tangible signs of civilization. The clapboard structures silhouetted against Devil's Dining Table signal the presence of a fishing station that would be inhabited throughout the summer by local fishing crews. Alpheus Spring Packard, who accompanied Bradford to Labrador in 1863, later described Henley Harbor in ways reminiscent of Bradford's painting:

> As we entered Henley Harbor the scene was unique. The strait was clear of ice, though a few days earlier the harbor had been packed with it, and remnants were stranded along the shore or carried hither and thither with the tides.
> The outlines of some of the pieces were beautiful; many were painted with green tints while the sun was high, but later in the afternoon the greens were succeeded by bright azure blues.[4]

Newfoundland, Labrador, and the Arctic inspired much of Bradford's mature work. For Bradford, the allure of the Arctic in particular was fueled by publications such as Elisha Kent Kane's *Arctic Explorations: The Second Grinnell Expedition in Search of Sir John Franklin, 1853, '54, '55* (2 vols., 1856). Bradford himself first visited the Arctic in 1861 and, except for

1862, returned annually for the next eight years. These expeditions culminated in 1869, a voyage that formed the basis for his own 1873 book, *The Arctic Regions: Illustrated with Photographs Taken on an Art Expedition to Greenland*. Monumental in scale (measuring more than 24 by 19 inches) and ambition, *The Arctic Regions* recounted the artist's voyage on the *Panther*, a 350-ton steamer that left from St. John's, Newfoundland, on July 3 on a three-month expedition, covering an astounding five thousand nautical miles. Bradford hired John Dunmore and George Critcherson, professional photographers from the Boston-based J. W. Black Studio, to document the voyage. *The Arctic Regions* included one hundred twenty-five original photographs, which provided the artist with inspiration for subsequent paintings. V.R.B.

NOTES

1. Quoted in John Dunmore, George Critcherson, William Bradford, and Sandra S. Phillips, "The Arctic Voyage of William Bradford," *Aperture* 90 (1983): 19.

2. Gordon Hendricks Research Files on American Artists, 1950–1977, Archives of American Art, Smithsonian Institution, reel 3002, excerpt from *San Francisco Daily Evening Bulletin*, August 5, 1876.

3. See William Grey, *Sketches of Newfoundland and Labrador* (Ipswich, Eng.: S. H. Cowell, Anastatic Press, 1858).

4. Alpheus Spring Packard, *Labrador Coast: A Journal of Two Summer Cruises to That Region* (New York and London: N. D. C. Hodges, 1891), 120.

4

WILLIAM BRADFORD

American, 1823–1892

Icebergs, circa 1868

Oil on panel, 10 × 15 in.

Signed "W^m Bradford" at lower right

Icebergs shows Bradford's fascination with both the scenery and the inhabitants of one of North America's northernmost regions along with his interest in the interplay of color, light, and shadow, particularly on

the most striking features of the Arctic landscape—icebergs. A cluster of large, color-soaked icebergs abut the shoreline and dominate the seascape, which is dotted with fishing vessels and flanked by rustic coastline dwellings. Clouds and sky, icebergs and ocean glow with color. Two fishermen in a shallow boat struggle to haul in their nets, signaling to the painting's viewers their rugged lifestyles and dependence on the sea for sustenance. Similar scenes appear throughout Bradford's sketchbooks from this period.[1] The similarity of this work with *Coast of Labrador* is obvious, as this painting could almost be a depiction of the same landscape from a different vantage point. A comparison of the two paintings reveals an aspect of Bradford's working methods,

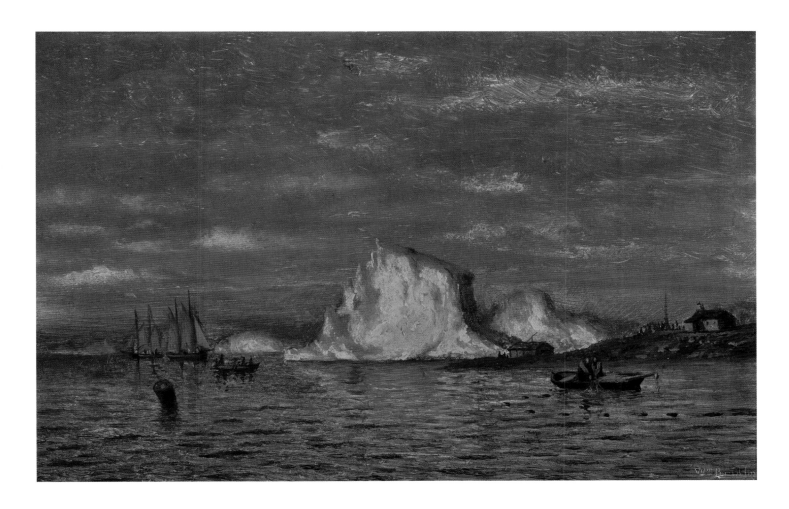

with vivid sketches such as *Icebergs* capturing the immediacy and atmosphere of the scene and providing the basic elements for larger, highly finished exhibition paintings like *Coast of Labrador*.

The Reverend David A. Wasson, a transcendentalist minister who accompanied Bradford to Labrador in 1864 on the schooner *Benjamin S. Wright*, described Bradford's awe and enthusiasm in depicting an unusually shaped iceberg. Wasson recalled:

Bradford worked at it like a beaver all the afternoon, and then directed the schooner to lie to through the night, that he might resume his task in the morning,—coveting especially the effects of early light. The ardent man was off before three o'clock. Nature was kind to him; he sketched the berg under a dawn of amber and scarlet, followed by floods on floods of morning gold; and returned to breakfast after five hours' work, half in rapture and half in despair. The colors, above all, the purples were inconceivable, he said, and there was no use trying to render them.[2]

V.R.B.

NOTES

1. William Bradford Papers, 1860–1893, Archives of American Art, Smithsonian Institution, Washington, D.C., reel 2674.

2. David A. Wasson, "Ice and Esquimaux," *The Atlantic Monthly* 15 (January 1865): 51.

5

ALFRED THOMPSON BRICHER

American, 1837–1908

Autumnal Landscape, 1866

Oil on board, 8¹¹⁄₁₆ × 18⁵⁄₁₆ in.

Signed and dated "A.T. Bricher 1866" at lower left

Alfred Thompson Bricher was born in Portsmouth, New Hampshire, and moved with his family to Newburyport, Massachusetts, when he was a young child. He opened his first studio there in 1858 at age twenty-one. That same year Bricher met William Stanley Haseltine, an American landscape painter who had studied in Europe and was on a sketching trip to Mount Desert, an island off the coast of Maine. Although an early biographer claimed Bricher was self-taught, he likely received instruction from Haseltine.[1] From 1859 until 1868, Bricher maintained a studio in Boston and made routine sketching trips throughout New York, New Hampshire, and Massachusetts, gaining recognition for his autumn landscapes. The young artist sketched scenes along the lower Hudson River and in the mountains of New Hampshire, his paintings similar to those of his contemporaries John Frederick Kensett, Albert Bierstadt, and Robert S. Duncanson.

The year 1868 was significant for Bricher, who married, moved to New York City, and began exhibiting at the National Academy of Design. Bricher turned to his most recognizable subject in the 1870s—coastal seascapes—and began experimenting with watercolors, a medium he pursued with acclaim for the remainder of his career. In the late 1870s and early 1880s, he briefly painted genre scenes, only to return to the coastal subjects that dominate his oeuvre. As an established artist, Bricher lived and exhibited in New York City, though he sketched throughout New England, until his death.

———•———

While the Hudson River Valley was a popular locale for artists to paint throughout the mid-nineteenth century, landscapes farther west became increasingly important. Bricher traveled to Minnesota in summer 1866, the same year he painted *Autumnal Landscape*. The bucolic, level terrain depicted in the work, along with its date, suggest *Autumnal Landscape* may be related to a small group of Minnesota scenes by Bricher.[2]

Around the same time Bricher traveled to Minnesota, he began collaborating with Boston-based lithographer Louis Prang, who is credited with perfecting chromolithography, a revolutionary industrial color-printing process, in the United States. Bricher's landscapes were among the first works Prang reproduced, which included a pair entitled *Early Autumn on Esopus Creek, N.Y.* and *Late Autumn in the White Mountains*. No chromolithographs of *Autumnal Landscape* have been located, though the painting is similar in composition and subject to these and other works reproduced as prints intended for a mass market. Reproducing Bricher's paintings allowed Prang to emphasize the technical virtuosity of chromolithography, which was unrivaled anywhere else in the world. To market his "American Chromos," Prang published a quarterly journal entitled *Prang's Chromo, A Journal of Popular Art* beginning in January 1868. Of Bricher's work, Prang wrote:

> Mr. Bricher is a well-known Boston artist, whose representations of American scenery, and especially of autumnal scenery, have always been received with much favor. Our chromos are reproductions of some of his most popular sketches. . . . They fill the room with a sense of beauty; and their glowing hues, so faithfully reproducing the parti-colored garb of autumn, are a constant pleasure to the eye as well as to the mind. . . . Prang's chromos are actually giving Democracy its art-gallery.[3]

The connection that Prang makes between American democracy and the landscapes is a common thread throughout this period. As early as 1835, Thomas Cole, the father of American landscape painting, asserted the specifically American beauty of fall foliage. That Bricher has likely painted a Minnesota scene suggests that he is asserting the continued spread of American democracy into western territories: Minnesota had become a state only eight years before, one of the last three to be created before the Civil War. V.R.B.

PROVENANCE: Questroyal Fine Art, LLC (New York, New York), 2015.

LITERATURE: Questroyal Fine Art, *Voyeurs in Virgin Territory: The Hudson River School Painters* (New York, NY: Questroyal Fine Art, LLC, 2015), illus., p. 11.

NOTES

1. "American Painters—Alfred T. Bricher," in *The Art Journal* 1 (1875): 340.

2. Rena Neumann Coen, "Alfred Thompson Bricher's Early Minnesota Scenes," *Minnesota History* 46 (Summer 1979): 233–236.

3. "Bricher's Landscapes," *Prang's Chromo, A Journal of Popular Art* 1 (September 1868): 1.

ALFRED THOMPSON BRICHER
American, 1837–1908
Long Island Sound, circa 1875
Watercolor, 20 × 6 in.
Signed "Bricher" at lower left

Long Island Sound exemplifies Alfred Thompson Bricher's work as a mature artist through his mastery of the watercolor medium and interpretation of picturesque coastal scenes along the eastern seaboard of the United States. In an article featuring Bricher in *The Art Journal* in 1875, an anonymous critic wrote:

> In 1873 [Bricher] became interested in water-colour painting, and in that year contributed his first drawing in that medium to the exhibition of the American Society of Painters in Water-Colours, and was at once elected a member of the institution. His water-colour works are remarkable for their force and brilliancy of tone.[1]

Bricher's watercolors were highly praised by his contemporaries. He transitioned from oils to watercolors in the early 1870s and quickly established himself among the leading watercolorists of his day. He was among the first generation of American artists to practice watercolor professionally; Winslow Homer, for example, began to exhibit watercolors at the same time.

In 1868, Bricher relocated from Boston to New York City, where he continued to maintain a relationship with chromolithographer Louis Prang of L. Prang and Company of Boston (see cat. no. 5). As with a handful of Bricher's oil paintings from the 1860s, Prang reproduced Bricher's

watercolors, including in 1891 a lithograph related to *Long Island Sound* entitled *Blue Point Oyster Boats*.[2]

In *Long Island Sound*, the oyster boats' soft reflections on the Sound's gentle waters belie the commercial realities of the era and the ecological devastation afoot. As the nineteenth century ended, decades of persistent overharvesting led oyster growers to replant New York–area beds with seed oysters sourced from the Chesapeake Bay of Virginia and Maryland. Named for the Long Island town of Blue Point, true "Blue Points" had ceased to exist as early as the 1820s, and Blue Point oysters of the late nineteenth century were largely not native to the Sound. Aided by seed oysters, Long Island Sound was the epicenter of East Coast oyster harvesting, annually producing 700 million oysters at the industry's height.[3] Oyster boats, like those seen in Bricher's watercolor, were thickly scattered over the water and constantly in motion. According to environmentalist and author Tom Andersen, the oystermen "hauled the dredges as many as six times in one drift of a thousand feet, yelling all the while, and at times

collapsing on deck, exhausted from the exertion."[4] Steam-powered oyster boats came into regular use in the last quarter of the nineteenth century, further decimating the oyster beds. Bricher's *Long Island Sound* is not only beautiful but nostalgic: like so many of his contemporaries' landscapes, it records a scene that had largely disappeared. V.R.B.

NOTES

1. "American Painters—Alfred T. Bricher," *The Art Journal* 1 (1875): 341.

2. The Miriam and Ira D. Wallach Division of Art, Prints and Photographs: Print Collection, The New York Public Library, "Blue Point oyster boats," New York Public Library Digital Collections, accessed February 4, 2018, http://digitalcollections .nypl.org/items/510d47db-c9e5-a3d9-e040-e00a18064a99.

3. Rowan Jacobsen, *A Geography of Oysters: The Connoisseur's Guide to Oyster Eating in North America* (New York: Bloomsbury, 2007), 124–125; Mark Kurlansky, *The Big Oyster: History on the Half Shell* (New York: Ballantine Books, 2006), 244.

4. Tom Andersen, *This Fine Piece of Water: An Environmental History of Long Island Sound* (New Haven: Yale University Press, 2002), 91–92.

7

JASPER FRANCIS CROPSEY

American, 1823–1900

Eagle Cliff, New Hampshire, 1872

Oil on canvas, 12 × 20 in.

Signed and dated "Cropsey 1872" at lower left

Born on his family's farm in New York, Jasper Francis Cropsey was raised in a deeply religious household. Active members of the Dutch Reformed Church, his parents stressed the importance of Christian values such as hard work and regular church attendance, a spiritual orientation that strongly marked Cropsey's later artistic development. Plagued by bouts of illness throughout his life, Cropsey likely took up drawing because he was forced to stay home from school.[1]

At the age of fourteen, Cropsey began a five-year apprenticeship to the architect Joseph Trench in New

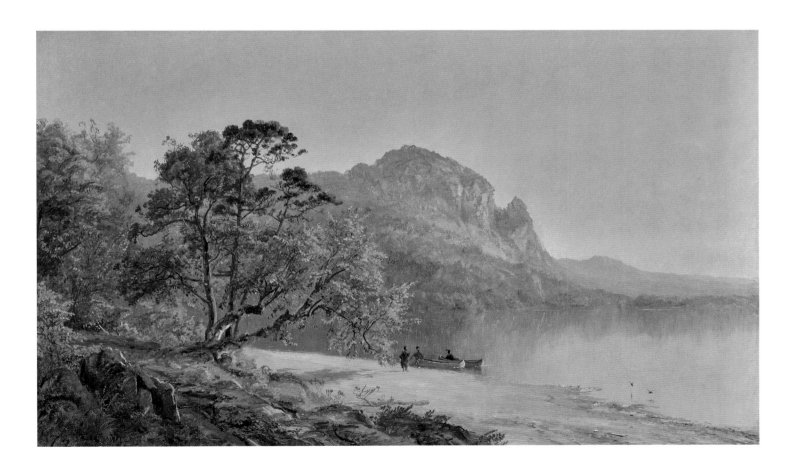

York City. Noting his talents in drawing, Trench hired the English artist Edward Maury to train Cropsey in watercolor in 1840; the artist largely taught himself oil painting practices. In June 1847, Cropsey and his new wife traveled to Europe, where they lived and worked for two years, primarily in London and Rome. Returning to England in 1856 and staying there for seven years, Cropsey hoped the time would not only allow him to engage with the tradition of British landscape painters but also promote his already growing international reputation. Upon his reentry to America, Cropsey quickly became known for his vibrant depictions of fall foliage, of which *Eagle Cliff, New Hampshire* is an excellent example.

———•———

Recognized for his accurate renderings of local topography, Cropsey returned to the dramatic rock formations of the White Mountains in New Hampshire throughout his career. Since the area was a popular tourist destination, guidebooks provided itineraries and identified monuments in the natural landscape, cementing their status as icons of the region for artists and tourists alike.[2] One such feature, depicted in this painting, is Eagle Cliff. According to the guidebook by Unitarian clergyman Thomas Starr King, "There are those to whom the sight of such a crag, sharply set at the angle of a mountain wall, is one of the most enjoyable and memorable privileges of a tour among the hills."[3] Encouraging viewers to take in the scene at sunset, King finds that the beauty of the changing light against the water inspires both poetry and a connection to the divine, a sentiment clearly shared by Cropsey.[4]

While his work is rooted in highly accurate, direct observation, Cropsey's religious background played a key role in his relationship to nature. For Cropsey, the study of the natural world allowed communication with God. With light infusing the entire painting, the landscape becomes an expression of God's presence. Depicting the lake at sunset, Cropsey reflects the sky and mountains in the water's glassy surface, creating a balanced and cohesive scene that radiates a diffuse, golden light.

Regarded as one of the premier painters of the American landscape in autumn, Cropsey combines vibrant reds, yellows, and greens to create a lush countryside that encircles the Native Americans at the center of the work. He incorporated these figures—not based on observation—to suggest their harmony with nature. While fall did not have the same religious connotations as spring's rebirth and renewal, autumn was considered a distinctly American season.[5] Cropsey's romanticized image of Native Americans in the painting further highlights this connection of both the season and the landscape with American identity, as he searches for an idealized American past. s.b.

NOTES
1. William S. Talbot, *Jasper F. Cropsey, 1823–1900* (Washington, D.C.: Smithsonian Institution Press, 1970), 16.

2. Weasley G. Balla, "Consuming Views: Art and Tourism in the White Mountains, 1850–1900," introduction in Weasley G. Balla, Roger E. Belson, and John J. Henderson, *Consuming Views: Art and Tourism in the White Mountains, 1850–1900: An Exhibition at the Museum of New Hampshire History, September 16, 2006–May 6, 2007* (Concord, NH: New Hampshire Historical Society, 2006), 11.

3. Thomas Starr King, *The White Hills, Their Legends, Landscape and Poetry* (Boston: William F. Gill & Co., 1876), 108.

4. Cropsey had painted the subject as early as 1858: *Eagle Cliff, Franconia Notch New Hampshire*, now in the North Carolina Museum of Art.

5. Bartholomew F. Bland, "The Landscape," in *Paintbox Leaves: Autumnal Inspiration from Cole to Wyeth* (Yonkers, NY: Hudson River Museum, 2010), 26.

THOMAS DOUGHTY

American, 1791–1856

Adirondack Mountain Scene (*Catskill Scenery*),
 circa 1828

Oil on canvas, 24 × 20 in.

Signed "T. Doughty" on riverbank at lower left
 middle ground

Born in Philadelphia, Thomas Doughty was among
the first generation of Hudson River School painters
who turned his attention exclusively to landscape
painting beginning in the 1820s. Initially trained
as a leather worker, he was largely self-taught as
a painter. He was also an avid outdoorsman, and
his landscapes were recognized for their fidelity to
nature. While these paintings demonstrate Doughty's
careful observation of the natural world, they are
not necessarily topographical but contrived to
show American landscape painting as an idealized
expression of national identity, paving the way for
later Hudson River School artists, such as Frederic
Edwin Church and Albert Bierstadt.

—————•—————

Using muted colors combined with soft, golden
lighting, Doughty's *Adirondack Mountain Scene* goes
beyond a faithful depiction of the natural world to
create an ideal America in which people and nature
peacefully coexist. Two large trees reach into the sky
from both sides of the painting to frame the human
presence in the landscape. On both shores of the
flowing river, figures engage with the natural world.
On the left side, a man is hunting in an outfit of
shades of blue and pink that are repeated throughout

the surrounding countryside. This harmonious representation of humanity in the landscape is further emphasized on the right, where another man chops wood in front of his home nestled in unfolding hills. A trailing puff of smoke from the chimney makes the scene welcoming, inviting viewers to imagine themselves in the scene.

According to art historian Barbara Novak, Doughty regularly included a single figure with his back turned as a motif to encourage contemplation—as if viewers are looking over the person's shoulder—and promote an ideal of humanity living in harmony with nature.[1] Enveloped by the land around them, both figures in this scene seem to have become one with the natural world. Although Doughty painted

Adirondack Mountain Scene at the outset of the interest in transcendentalism, such an expression of unity with the natural world asserts a cohesion with a divine presence that was certainly in accord with the newly popular philosophical movement. Doughty's signature reinforces this. Scratched into the riverbank at the left-hand side of the painting, it literally becomes part of the landscape, adding to the overall feeling of connection between the artist—and, by extension, humanity—and his environment. s.b.

NOTE

1. Barbara Novak, *Nature and Culture: American Landscape Painting, 1825–1875* (New York: Oxford University Press, 1980), 190.

9 *[see also page 19]*

ASHER B. DURAND

American, 1796–1886

Pastoral Landscape, 1857

Oil on canvas, 10⅝ × 16¹¹⁄₁₆ in.

Signed and dated "AD 1857" at lower left

10 *[see also page 20]*

ASHER B. DURAND

American, 1796–1886

Pastoral Landscape, 1866

Oil on canvas, 18¾ × 29¹⁄₁₆ in.

Signed and dated "AB Durand 1866" at lower right

Born into a New York family, Asher B. Durand began his career as an apprentice to Peter Maverick, an engraver working in Newark, New Jersey. As an apprentice, Durand cultivated a meticulous understanding of composition, shadow, and light. The five-year apprenticeship led to the formation of P. Maverick, Durand & Co. through which Durand found financial success in commercial engraving, such as designs for bank notes, business cards, book illustrations, and tickets, allowing him to support himself, his young family, and his pursuit of more artistic projects. Notable accomplishments from this period include engravings after two famous American paintings, John Trumbull's *The Declaration of Independence* and John Vanderlyn's *Ariadne*, which solidified his reputation as America's most accomplished engraver.

In his late thirties, and at the encouragement of his patron Luman Reed, Durand gave up engraving and began to paint portraits of prominent American politicians, which included the likenesses of Senator Henry Clay, former president James Madison, and President Andrew Jackson. At age forty-one, Durand experienced another turning point when he accompanied Thomas Cole, America's leading landscape painter, on a sketching trip to the Adirondack Mountains in New York. Mentored by Cole, Durand started to pursue oil painting and submitted works to prominent exhibitions. From 1840 to 1841, he accompanied John Kensett and John Casilear—also engravers set on becoming landscape painters—to Europe. Disappointed with European landscape painting, except for the work of John Constable, Durand returned to the United States determined to promote an American school, his agenda described in a letter to Cole being to paint "the beauties of my own beloved country."[1]

Durand earned a reputation as the consummate American artist—self-educated, self-made, physically active, brave, self-reliant, and enterprising. On his annual summer sketching trips into the Adirondacks, Catskills, and White Mountains, he carried pigskins of oil paint, palettes, easels, food, and camping equipment. What we may perceive as sedate pastoral scenes would have been read by nineteenth-century viewers as beauty captured through athleticism, bravery, and brute strength in rough wilderness. As one reviewer noted, "Of our celebrated rugged individualism Asher B. Durand is in the field of art one of the sturdiest examples."[2]

Within a decade, Durand became an authoritative presence in American painting. He taught, published essays, helped found and administer major art organizations in New York (including the National Academy of Design, of which he became president), exhibited at important venues, and gained prominent commissions in oil. Following Cole's example, he mentored a generation of younger artists, which included authoring a series of essays for his son John's publication, *The Crayon*, under the title "Letters on Landscape Painting." Durand's technical suggestions focused on formal elements of composition, line, and color, but he also encouraged the further development of a

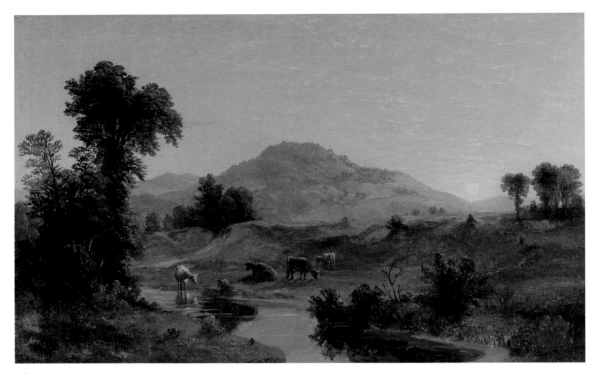

9

native school of American landscape painting wholly separate from European traditions. In his "Letters," he asked of his readers, "Why should not the American landscape painter, in accordance with the principle of self-government, boldly originate a high and independent style, based on his native resources?"[3] Durand most assuredly succeeded in doing so.

———·———

Both of Durand's *Pastoral Landscape* paintings are verdant views filled with leafy trees, gently grazing livestock, and purple mountains fading into the horizon. Painted almost a decade apart, they are quintessential examples of his style and subject matter, celebrating America's native resources and appealing to his patrons' nostalgia. Absent human presence, the scenes place viewers in a position to observe America's abundance, the cultivation of which Durand acknowledges by including domesticated cattle within

the expanding wilderness of forests and mountains softly receding into the background.

If the subject matter manifests a sense of American identity distinctly tied to the abundance and cultivation of natural resources and a school of American landscape painting, the variation in size between the two paintings suggests the realities of the art market in urban East Coast centers and the popularity of commissioning different-sized paintings to fill home decorating needs. From his "Letters" to younger artists, it is clear that Durand was keenly attentive to the desires of his "rich merchant and capitalist" patrons, whom he claimed purchased landscape paintings as an "oasis in the desert" and a "refreshing influence" within the city. He created these and other quietly bucolic views for domestic spaces, such subjects accounting for a large share of Durand's oeuvre and suggesting their popularity in New York's art market.

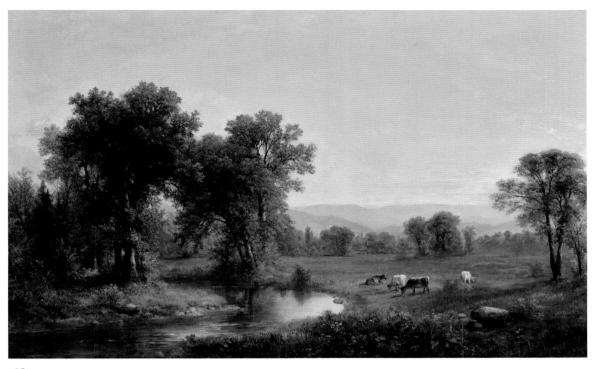

10

For Durand, these "quiet and familiar scenes" were "more than outward beauty, or piece of furniture."[4] He advised younger artists and readers of *The Crayon* that such distilled visions of American land—regardless of size or display—aimed to awaken childhood reminiscences of being at play in nature, of instilling national pride, and of promoting a desire for escape from the "discordant clamor and conflict of the crowded city" to the peacefulness of the countryside.[5] Durand wanted his paintings to be "companionable, holding silent converse with the feelings, playful or pensive" and "touching a chord that vibrates the inner recesses of the heart" in his patrons.[6] By gazing at the warm colors, expert shading, and minute details of the foliage and water, viewers are invited to imagine a leisurely stroll, a swim, a picnic, a hike into this scene, and to partake of healthful fresh air in the wilderness.[7]

Durand aimed not to imitate but to represent the natural world. For artists just starting out, he advised copious study of nature's details in pencil and then in oil—leaves, tree bark, grasses, rocks.[8] His "Letters" offer specific technical advice on executing these, as well as an entire section devoted to the study of trees—their lines, the mass of their foliage, and their shadows and transparencies.[9] Durand also suggested studying all the "simple and solid" parts of the landscape individually—"rocks and tree trunks, and after these, earth bank and the coarser kinds of grass, with mingling roots and plants . . . with even botanical truthfulness," but cautioned that such exacting fidelity will not work with foliage or running water, which required "a knowledge of their subtlest truths and characteristics."[10] Durand's *Pastoral Landscape* paintings include minute detail and a synthesis of nature within the foliage of the foreground, where individual blades of grass and leaves are distinguishable. The mirrored surfaces of

the running water and the copse of trees, with areas of shadow and transparency, offer a view consistent with how nature is seen. In other words, Durand's technique allowed his viewers to experience the trees, smell the fresh breeze, hear birds calling or cattle lowing, and feel the landscape beneath their feet, offering them a respite from an increasingly industrial age. M.O.

PROVENANCE: 1857 *Pastoral Landscape*: Christie's, New York, Important American Paintings, Drawings & Sculpture, May 26, 1999. 1866 *Pastoral Landscape*: Questroyal Fine Art, LLC (New York, New York); Menconi & Schoelkopf Fine Art, LLC (New York, New York); Questroyal Fine Art, LLC (New York, New York); Private collection.

EXHIBITION: Questroyal Fine Art, LLC (New York).

NOTES

1. Linda S. Ferber, "Asher B. Durand, American Landscape Painter," in *Kindred Spirits: Asher B. Durand and the American Landscape* (New York: Brooklyn Museum, 2006), 138–139.

2. Frank Jewett Mather, Jr., "The Hudson River School," *The American Magazine of Art* 27 (June 1, 1934): 300.

3. A. B. Durand, "Letters on Landscape Painting. Letter II," *The Crayon* 3 (January 17, 1855): 34–35.

4. A. B. Durand, "Letters on Landscape Painting. Letter IV," *The Crayon* 7 (February 14, 1855): 97–98.

5. Ibid.

6. Ibid.

7. Ibid.

8. A. B. Durand, "Letters on Landscape Painting. Letter III," *The Crayon* 5 (January 31, 1855): 66–67.

9. A. B. Durand, "Letters on Landscape Painting. Letter V," *The Crayon* 10 (March 7, 1855): 145–146.

10. Ibid.

11 *[see also page 44]*

GEORGE FORSTER

American, 1817–1896

Still Life with Fruit and Nest, 1869

Oil on panel, 16½ × 12½ in.

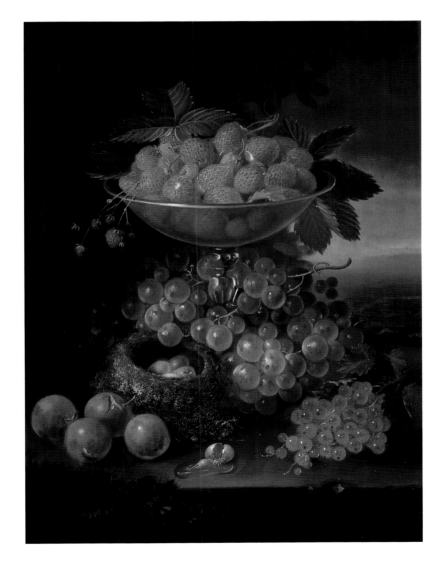

Little is known about the life of still-life painter George Forster. Born in the Kingdom of Bavaria (now part of Germany), he immigrated to the United States in 1865, along with his wife and seven children. He exhibited paintings at the National Academy of Design in 1870 and at the Brooklyn Art Association in 1879 under the name of Foster (his name was frequently misspelled this way). Forster is often confused with his two sons, Henry and George Jr., who were also artists. He lived in Brooklyn until his death.

———

Forster was especially skillful at rendering a stunning array of textures, which enabled him to create convincing trompe-l'oeil illusionism. In this painting, a warm glow permeates the multi-tiered, pyramidal composition of fruit wreathed in leaves. A bountiful and balanced display of strawberries, white grapes, and red currants glistens with a succulent sheen, accented through high notes of white paint. An atmospheric landscape glows behind the display. Delicate brushwork, requiring a masterful and steady hand, details the decorative, crystalline neck of the fruit bowl and showcases the grapes' delicate but sturdy translucence.

What makes this German-influenced, small-scale still life special is the moss-coated bird's nest with four eggs, the nest being Forster's signature motif. A fifth egg has rolled out of the nest and cracked upon the chipped wooden tabletop, the viscous albumen of the

shattered egg glistening and seeping across the table in a rounded glutinous pool and carrying with it the unpunctured, flaxen yolk. Art historically, the broken egg has been a classic emblem of *vanitas*, a metaphor for the inevitability of death. Other elements in Forster's plenteous assemblage seem also to be an allegory on the cycles of life. The nest of unbroken eggs may symbolize the anticipation of birth. Shading the nest just above is a small sprig of undersized strawberries in early development. Crowning in early spring, these small berries suggest infancy. The plump vitality of the ripe grapes, currants, and other strawberries may denote maturity, while the splitting skin of some of the plums indicates overripeness or decline.[1] S.G.

PROVENANCE: Christie's, November 29, 2007, lot number 79.

NOTE

1. For an exploration of the imagery associated with *vanitas* still lifes, see Raymond J. Kelly, *To Be or Not to Be: Four Hundred Years of Vanitas Painting* (Flint, MI: Flint Institute of Arts, 1996); and S. Ebert-Schifferer, *Still Life: A History* (New York: Abrams, 1999), 14, 72, 147.

12 *[see also page 43]*

JOHN FRANCIS

American, 1808–1886

Still Life with Currants, circa 1870

Oil on canvas, 12 × 14 in.

Born in Philadelphia, John Francis became the leading practitioner of luncheon and dessert still-life painting. Largely self-taught, he worked from about 1832 to 1845 as a portrait painter in Pennsylvania and nearby states. In 1849, he began to exhibit his still lifes at the Pennsylvania Academy of the Fine Arts and the Philadelphia Art Union. Following in the tradition of earlier Philadelphia artist Raphaelle Peale, Francis capitalized on the popularity of still-life painting in this city, producing his earliest dated surviving still life in 1850. By 1854, he was working exclusively in the genre. His last known exhibition was in Louisville, Kentucky, in 1873. Few of his paintings can be dated after 1872 and none after 1880, possibly due to his declining health or waning public demand for imagery of bountiful nature.

Nearly all of Francis's still lifes, aside from a dead game painting and two floral still lifes, depict succulent fruits and tempting desserts. Francis was known to have created copies of his own paintings, and his style underwent little change over the course of his career. Art historian William H. Gerdts points to Francis's distinction among mid-century still-life specialists as being exceptionally painterly, setting him apart from his contemporaries Severin Roesen, George Hall, and others. Francis applied his paint more loosely, imbuing a rosy, petal-soft glow to solid and assured forms of harvest, cloth, and ceramics.

Still Life with Currants demonstrates Francis's typical horizontal composition yet departs from his usual variety of edible fare by presenting red currants as the sole and central subject. Francis sets the currants in front of a window that opens onto a landscape, placing an abundant bunch of freshly picked currants in the foreground and a bowl of currants ready for eating or cooking behind. Currants are a quintessential summer fruit, made into desserts, jellies, and liqueurs. The fruit was especially prized in northern Europe, but American horticulturalists took great delight in developing and presenting new varieties (the favorite was Red Dutch, prized for its sweet, rich flavor and bright red color).[1] Traditionally, European iconography imbues red currants with religious and social symbolism, representing Christ's blood or the hope of a fertile marriage. Here the currants suggest the fecundity of American nature. S.G.

PROVENANCE: Kennedy Galleries (New York, New York), 1995.

NOTE

1. See Cuthbert W. Johnson, *Farmer's and Planter's Encyclopedia of Rural Affairs* (Philadelphia: J. B. Lippincott, 1869), 376.

13 *[see also page 35]*

SANFORD ROBINSON GIFFORD

American, 1823–1880

Lake Champlain, 1860

Oil on canvas, 5¼ × 9½ in.

Signed and dated "S R Gifford 1860" at lower left

Sanford Robinson Gifford was a second-generation Hudson River School painter, one of the few among his contemporaries to be born and raised in the Hudson River Valley. From 1842 to 1844, he attended Brown University, where he joined his brother Charles. Although the university did not offer instruction in the arts, Gifford later recalled that he was interested in fine art as a result of his brother's influence: "My oldest brother had a taste for the fine arts; and one of the greatest pleasures of my boyhood was in looking at and studying the miscellaneous collections of engravings (many of them from pictures in the National Gallery) which covered the walls of his room."[1]

Gifford left college before graduation and moved to New York City in 1845 to devote himself to the pursuit of art, turning his attention to landscape painting in 1846 and embarking on a sketching trip to the Catskills and the Berkshires. Decades later, Gifford wrote to his artist-friend Jervis McEntee to join him in the Catskills "to see the color. I don't think I can feel quite easy in my conscience to go to town without paying my respects to the mountains."[2] This initial sketching trip proved profoundly influential, as he later recalled: "Having once enjoyed the absolute freedom of the landscape artist's life, I was unable to return to portrait painting. From this time my direction in art was determined."[3]

Gifford's formative years paved the way for his grand tour of Europe. In the summer of 1855, he visited England, where he saw and was influenced by Joseph M. W. Turner's radiant painterly effects. He traveled throughout the Continent, eventually settling in Rome in the spring of 1856. There, he painted one of his largest works, *Lake Nemi* (Toledo Museum of Art), which received great acclaim at the National Academy of Design in 1857. When he returned to New York the following year, he rented studio number 19 in the famed Tenth Street Studio Building, becoming a neighbor of other painters.

———·———

Gifford saw Lake Champlain as the American counterpart to Lake Nemi. He created this charming and lively oil sketch of Lake Champlain, not far from Mount Mansfield, on a sketching trip in 1860. He was one of the first artists to sketch atop Mount Mansfield, and "pronounced the place equal in interest to Mount Washington and in every way a charming spot."[4]

Gifford and his fellow landscape painters in the Tenth Street Studio Building typically spent the spring and summer sketching in the country and fall and winter making fully realized paintings in the city. These artists went to great lengths to discover and locate the best views, which ranged from grand to idyllic and serene. Recognizing the challenges involved, a critic in September 1860 noted:

> Our artists are quite generally "out of town"— which means gone to the antipodes, or any

Sanford Robinson Gifford (American, 1823–1880), *Lake Nemi*, 1856–1857. Oil on canvas, 39⅝ × 60⅜ in.
Toledo Museum of Art, Purchased with funds from the Florence Scott Libbey Bequest in Memory of her Father,
Maurice A. Scott, 1957.46. Photo Credit: Photography Incorporated, Toledo.

where else that a good sketch can be had. The hope of *that* great picture, of which every artist dreams, sends them into every imaginable locality in quest of *the* sketch. They straddle mountains, ford rivers, explore plains, dive into caves, gaze inquisitively into clouds . . . always returning safely home in the golden October, with a lean pocket and plethoric portfolio, ready for commissions and praise.[5]

This sketch presents an elevated view of Lake Champlain, situated between the borders of New York, Vermont, and Québec. Its portable scale suggests Gifford captured the scene *en plein air*. The painting

is one of several small sketches Gifford made during his 1860 sojourn. The artist's energetic handling of paint is evident from foreground to background, building up the surface and helping to emphasize space. Impasto, in the foreground branches, leaves, and rocks, provides three-dimensionality that contrasts with the flatter strokes and more subdued tones in the middle ground and background. Gifford's use of paler hues in the distance heightens a sense of depth in this stretch of land. The scene's breadth is further emphasized by the extreme horizontal format of the painting, its length nearly double its width, creating a panoramic view.

Gifford was particularly perceptive to the nuances

of light and atmosphere when sketching outdoors. Critics recognized his hypersensitivity and praised him for rendering these characteristic effects in his landscapes: "The aerial perspective is admirable; the mist is a palpable, floating mist . . . the spectator looks through the vaporous atmosphere so well given, to mountains beyond mountain."[6] *Lake Champlain* appears to be not a specific preliminary study for a larger finished painting but rather a study of the atmospheric aspects that attracted Gifford on his excursions. L.S.

PROVENANCE: Elihu Gifford (Hudson, New York), acquired circa 1881; Private collection; Thomas Colville Fine Art (Guilford, Connecticut).

LITERATURE: Aimee Marcereau DeGalan, "A Beckoning Country: An Artist's Journey to the Champlain Valley," in Robert Hull Fleming Museum, *A Beckoning Country: Art and Objects from the Lake Champlain Valley* (Burlington, VT: The Robert Hull Fleming Museum, 2009), 4–5, fig. 1; The Metropolitan Museum of Art, New York, *A Memorial Catalogue of the Paintings of Sanford Robinson Gifford, N.A.* (New York: New York Press or Press of Francis Hart & Col., 1881), no. 194; Ila Weiss, *Poetic Landscape: The Art and Experience of Sanford R. Gifford* (Newark: University of Delaware Press; London and Toronto: Associated University Press, 1987), 218, color plate 8.

NOTES

1. Sanford Robinson Gifford, Letter to O. B. Frothingham, Esq., Hudson, November 6, 1874, Sanford Robinson Gifford Papers, 1840s–1900, Archives of American Art, Smithsonian Institution, Washington, D.C.; referenced in Ila Weiss, *Sanford Robinson Gifford (1823–1880)* (New York and London: Garland Publishing, 1997), 6.

2. Sanford Robinson Gifford, Letter to Jervis McEntee, October 8, 1962, Jervis McEntee Papers, 1848–1905, Archives of American Art, Smithsonian Institution, Washington, D.C.

3. Gifford, Letter to Frothingham.

4. "Fine Arts," *The Home Journal* (September 4, 1858): 3; quoted in Franklin Kelly, "Mount Mansfield," in *Hudson River School Visions: The Landscapes of Sanford R. Gifford*, ed. Kevin J. Avery and Franklin Kelly (New York: The Metropolitan Museum of Art; New Haven and London: Yale University Press, 2003), 108.

5. Critic in *Cosmopolitan Art Journal* (September 1860); quoted in Eleanor Jones Harvey, *The Painted Sketch: American Impressions from Nature, 1830–1880*, frontispiece; quoted in Lee A. Veder, *Jervis McEntee: Painter-Poet of the Hudson River School* (New Paltz, NY: Samuel Dorsky Museum of Art, State University of New York at New Paltz, 2015), 18.

6. "Exhibition at the Academy of Design," *New York Semi-Weekly Tribune*, May 17, 1859; quoted in Ila Weiss, *Poetic Landscape: The Art and Experience of Sanford R. Gifford* (Newark: University of Delaware Press; London and Toronto: Associated University Press, 1987), 218.

14 *[see also page 2]*

WILLIAM HARNETT

American, b. Ireland, 1848–1892

*Still Life with Book, Pitcher, Pipe, Tobacco
and Matches with a Newspaper*, 1878

Oil on canvas, 18 × 15 in.

William Michael Harnett was nineteenth-century America's foremost trompe-l'oeil painter. His painting *After the Hunt* became a major attraction at a celebrated New York bar on Warren Street, endlessly admired starting in 1886. But art critics decried his art: "Only a very few artists of merit have ever condescended to apply their skill to the sole purpose of imitation, making so-called pictures out of dead objects painted to deceive the eye as far as possible. . . . The real fact is that this charge of inferiority is justified by the consideration that this imitative work is not so difficult as it seems to the layman."[1] Such condemnation reflects how trompe-l'oeil paintings like Harnett's were more at home in the private refuge of a gentleman's study or other manly haunts of the city than exhibition spaces.

Born in Clonakilty, County Cork, Ireland, amid the potato famine, Harnett immigrated as an infant with his family to Philadelphia and was raised there. He studied as a metal engraver at the Pennsylvania Academy of the Fine Arts (1866–1869), working professionally in New York as a silver engraver for the Cooper Union and the National Academy of Design. He used his engraver's precision to excel in his 1873 transition to painting still lifes. After returning to Philadelphia in 1876 in time for the Centennial Exposition, Harnett rendered nontraditional, vernacular objects with astonishing realism. These pictures featured the trappings of successful men; bound books, stationery, newspapers, writing

implements, and both metal and paper currency were all common depictions in his work. Materials affiliated with masculine culture were also prominent, including specialty drinking vessels and smoking paraphernalia such as pipes, tobacco boxes, and matches. Distinctive to Harnett was his incorporation of musical

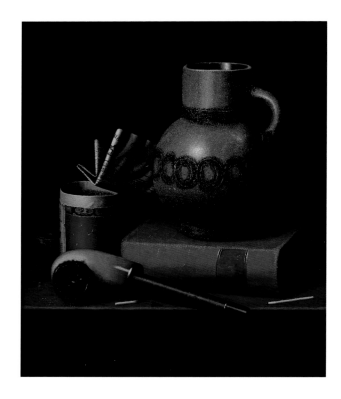

pleasures and other "bric-a-brac" valuables, including sheet music as well as exquisite string and wind instruments.[2]

Harnett's later work demonstrated the effect of six years' residence in Europe, from 1880 to 1886. Beginning in London but then moving to Germany, he worked mostly in Munich for four years before spending his last year in Paris. Seeing Munich's collections rich in seventeenth-century Dutch trompe l'oeil, he responded by including traditional allegorical elements such as skulls—a reminder of the brevity of life—and sharpening the deceptive illusionism of his refined tabletop groups and depictions of objects hanging against walls or doors. During his final years, Harnett suffered from rheumatism; he died in New York City in 1892.

———•———

Harnett's exacting precision in his small-scale canvases brings objects within graspable distance. Each work becomes a toy box of visual delight, a must-have for a study or smoking room. Instead of fruit and flowers, ideal for dining rooms or parlors, Harnett's objects include the things that interest mostly men: musical instruments, hanging game, tankards, horseshoes, secondhand books, firearms, and currency.

In *Still Life with Book, Pitcher, Pipe, Tobacco and Matches with a Newspaper*, visually complicated and pleasantly illusionistic objects occupy a shallow space. Harnett convincingly renders textured stoneware, creased newsprint, a worn leather-bound volume, aromatic flakes of ready-rubbed tobacco, and a figural, scuffed meerschaum pipe. Earthy, robust, and refined, the composition of Harnett's cosmopolitan assemblage guides the eye to the cobalt blue of the tobacco tin wrapping with its frayed rim, as well as the crimson label of the book's spine framed in a thin gold border.

Harnett's subtler notes emerge from the foreground pipe, its stem protruding off the table's edge into the viewer's space. Finely painted bite marks on the pipe's mouthpiece, the orange glow of the embers smoldering within the shadowed pipe bowl, and a delicate pile of ashes spilling from the overturned chamber collectively bestow a sense of presence and immediacy. Harnett's play with ephemerality sparks a moment haunted by the match-igniting fingers and puffing mouth of the pipe's smoker. Two matches bookending the pipe, one blackened and the other unstruck, suggest a cycle of creation and destruction, beginning and end. These temporal references are underscored by the folded newspaper, with its semi-legible date of "____ 19, 1878."

Harnett's Rhenish-style jug, a globular gray and blue vessel with a speckled surface and embellished with circular motifs that ring its body, is historically categorized as a drinking container for alcoholic beverages such as beer and spirits. Beginning in the 1860s and lasting into the twentieth century, the revival of the Rhenish stoneware tradition in Germany stands as a marker of transatlantic colonial exchange and the strong influence of German culture in the United States in the second half of the nineteenth century.[3] Haphazardly placed between the reading material, the tantalizing vice hinted at in the vessel is reinforced by the tobacco use, creating a composition balanced between a gentleman's decadence and erudition. S.G.

NOTES

1. "Academy of Design. Fifty Fourth Annual Exhibition. Fourth Article," *New York Tribune*, April 26, 1879, 5.

2. Sylvia Yount, "Commodified Displays: Bric-a-Brac Still Lifes," in *William Harnett,* ed. Doreen Bolger, Marc Simpson, and John Wilmerding (Fort Worth, TX: Amon Carter Museum, 1992).

3. David R. M. Gaimster, *German Stoneware, 1200–1900: Archaeology and Cultural History* (London: British Museum Press, 1997), 251, 325; and Ivor Noël Hume, "Rhenish Gray Stonewares in Colonial America," *Antiques* 2 (1967): 349–352.

15

WILLIAM M. HART

American, b. Scotland, 1823–1894

Coast of Maine, 1868

Oil on canvas, 15 × 24 in.

Signed "W^m Hart 68" at lower left

William MacDougal Hart was born in Paisley, Scotland, and immigrated as a child with his family to Albany, New York, in 1831. Unlike his elder brother, James MacDougal Hart, who studied art in Düsseldorf, Hart began his career as an apprentice to a carriage painter for Eaton and Gilbert Carriage Company in Troy, New York. Mostly self-taught, he had transitioned by 1834 to portraiture and landscape painting, for which he is best known. Setting up shop in his father's woodshed, Hart worked diligently and soon attained a reputation as an itinerant portrait painter. He also painted landscapes for additional income, as portraits required several sittings and thus took much longer to complete.

In 1849, Hart traveled to Scotland, where he spent three years filling his sketchbooks with Highland views. He returned to New York City in 1853 and became an associate and then a full academician of the National Academy of Design. By the end of that decade, he was wholly focused on American landscape painting and involved in local artists' organizations. He was unanimously voted the first president of the Brooklyn Academy of Design in 1865, was a founding member of the American Society of Painters in Water Color in 1866, and served as the latter's president in 1870 and 1872. Hart made many trips to Maine to paint landscape and coastal scenes, finding acclaim among art critics, his fellow painters, and patrons in New York for his depictions of the state's natural beauty and majestic light.

———·———

By 1868, Hart's dawn and twilight views of Maine had earned him distinction for his ability to capture light effects along the coast. In an 1887 interview about his Maine subjects, Hart stated, "A picture is a song—a piece of music. In it one expresses, it may be, the sentiment of color, or the hour, or place."[1]

Hart was tremendously successful in capturing the nuances and mood of Maine's sunrises and sunsets. An 1875 *Art Journal* essay described his Maine seascapes as the epitome of his "poetic fancy," offering an "exquisite treatment of detail, unity of sentiment, and fidelity . . . recognized as among his strongest works."[2] The reviewer identified Hart's strength as "the portrayal of a late sunset when the last rays of light, direct and reflected, are sent flashing across the landscape, and mingling every object within its influence, as it were, in one universal glow."[3] *Coast of Maine* exemplifies this description, and paintings like it were in demand by patrons who had vacationed in Maine or favored decorating their city homes with refreshing, luminous views of the sea.

In *Coast of Maine*, fading sunlight bathes the landscape. Land and sea are darkening, the soft rays of

light reflect on the distant islands, the spray of waves hits the rocky shore, and the white lighthouse stands sentinel in the distance. In the foreground, cattle are settled on the grassy knoll, and the craggy cliffs glisten with sea mist and form a barrier between the viewer, the islands and edge of the bay in the distance, and the open sea to the right. For Hart, cattle replace human figures because they "belong more naturally to the landscape . . . the conditions of the climate, the torrid sun prevent figures taking an important place in outdoor life."[4] On the horizon to the right, ships sail toward the bay and its harbor, an acknowledgment of Maine's fisheries and import/export trade in lumber and other natural resources, juxtaposing wilderness

with human enterprise. Above, cumulus clouds gently separate to reveal a clear blue sky, evidence of the end of a perfect day for sketching outdoors and enjoying the sea. M.O.

PROVENANCE: Godel & Co. Fine Art (New York, New York), 1999.

NOTES

1. "Talks with Artists," *The Art Amateur* 2 (July 1887): 35.
2. "American Painters—William Hart," *The Art Journal* 1 (1875): 246–247.
3. Ibid.
4. "Talks with Artists," 35.

16 *[see also page 49]*

THOMAS HICKS

American, 1823–1890

Frugal Meal, 1850

Oil on board, 11½ × 12¼ in.

Signed and dated "T Hicks 1850" at lower right

Apprenticed as a carriage painter at a young age to his cousin the painter Edward Hicks, Thomas Hicks became known as a skillful portrait painter. At the encouragement of his father, he pursued training at the Pennsylvania Academy of the Fine Arts, followed by sporadic study at the National Academy in New York City from 1838 to 1845.[1] Between 1845 and 1849, he studied painting in Europe, traveling from England to Italy and later to France. Upon his return to the United States, he settled in New York, where his portraits became highly regarded. One of his most famous likenesses featured Abraham Lincoln shortly after his presidential nomination in 1860, which is thought to be the first painted portrait of the president. Though Hicks became popular for portraits such as these, he was also a prolific genre and landscape painter.

———•———

An intimate genre scene, *Frugal Meal* depicts a young girl seated in a country kitchen holding a bowl of milk for her dog. Flanked on both sides by animals, the girl is absorbed in her own internal world. Gazing downward, without a specific object to catch her eye, she seems unable to address the disarray that surrounds her; even her right shoelace is undone. A close look around the kitchen reveals the room's relative chaos. While the door has been left open for the animals to come inside, items such as a spoon and

an oven mitt have fallen on the floor. The disorder is reinforced by the cat that seems to have just jumped on the bench, pushing the fresh produce to the floor. The animals gaze at each other, the dog pricking up its ears with interest and the cat tensing its back legs and tail. This interaction is lost on the girl who sits between them, unaware that her kitchen might descend into further chaos with their possible conflict. The painting's moral title, *Frugal Meal*, may have been added later, as it does not address the confusion of the scene.

According to art historian David Tatham, kitchen scenes were a popular subject for Hicks and other American artists of the era, particularly in the 1860s. These domestic views expressed a way of American life that was slipping away.[2] While Hicks's kitchen interiors often share this nostalgic tone, this work—which recalls seventeenth-century Dutch paintings of households in purposeful disarray—is more complicated and encourages viewers to become absorbed in its different vignettes. S.B.

PROVENANCE: Grand Central Art Galleries (New York, New York), 1944; IBM International Foundation Collection (New York, New York); Sotheby's, May 25, 1995.

EXHIBITIONS: National Academy of Design, 1890; IBM traveling exhibition, *Small Paintings by Americans*, September 1967–January 1969; IBM Gallery (New York), *American Painters of the Nineteenth Century*, January 1969–July 1971; IBM Gallery of Science and Art (New York), *Selected Works from the IBM Collection*, November 1985–January 1986.

LITERATURE: Maria Naylor, ed., *The National Academy of Design Exhibition Record, 1861–1900*, 2 vols. (New York: Kennedy Galleries, 1973), vol. 1, 436; Letha Clair Robertson, "The Art of Thomas Hicks and Celebrity Culture in Mid-Nineteenth Century New York" (Ph.D. diss., University of Kansas, November 2010).

NOTES

1. David B. Dearinger, ed., *Paintings and Sculpture in the Collection of the National Academy of Design, 1826–1925*, vol. 1 (New York: Hudson Hills Press, 2004), 268.

2. David Tatham, "Thomas Hicks at Trenton Falls," *American Art Journal* 15 (Autumn 1983): 13.

17

CLAUDE RAGUET HIRST
American, 1855–1942
Still Life with Book and Pipe, circa 1890
Oil on canvas, 11½ × 15½ in.

Claude Hirst is actually Claudine Hirst. Born in Cincinnati, Ohio, Claudine was the eldest of two daughters of Juliet and Percy Hirst. As a descendant of Pennsylvania Congressman Henry Wynkoop, she belonged to an old, elite family. When she was seven years old, her family relocated to Clifton, a wealthy suburb of Cincinnatti, which was also home to a burgeoning artist community. Hirst enrolled in painting lessons at age ten, taking dance lessons that same year with a "little fat-boy who was too shy to ask the girls to dance"—William Howard Taft, future president and Supreme Court justice.[1]

During the mid-1870s, Hirst trained at the McMicken School of Drawing and Design, learning three-dimensional drawing and woodcarving, and was part of the circle of women designers in Cincinnati who contributed their talents in design (especially pottery painting) to the Philadelphia Centennial International Exhibition in 1876. Although an accomplished artist and skilled teacher, Hirst chose a gender-deceptive pseudonym to avoid the negative association of "woman artist" with "amateur" that was prevalent during her time. Hirst chose to shorten her name to her initials and surname in the 1872 Cincinnati Industrial Exposition, her entries labeled "Miss C. F. Hirst." She subsequently truncated her name to "Claude" to eliminate any possible feminine identification, appearing in catalogues as "Claude Raguet Hirst" from then on.

In 1880, Hirst moved to New York and set up a studio in Greenwich Village. She studied with the artists Agnes Dean Abbatt, Charles Courtney Curran, and George Henry Smillie, during which time she married the landscape painter William Crothers Fitler. Her early New York work consisted primarily of flower still lifes in watercolor, and she joined the Woman's Art Club of New York and the American Watercolor Society. Hirst's turn to the genre of the bachelor still life was spurred in part by a neighbor, William Harnett, whose studio on 14th Street was only two doors down from hers. Hirst created several pipe and tobacco still lifes, one purchased by sugar baron H. O. Havemeyer. One of her paintings was chromolithographed as a Boston lager beer advertisement; another sold to a men's club in Chicago. Her success as a female artist painting specifically masculine subjects was extraordinary for the time.

———·———

Hirst emphasized that her primary inspiration was not Harnett but rather her husband's unkempt belongings that she observed every day. She recalled, "[Fitler] was not very orderly. His tobacco things were always around and one day I noticed what an attractive group they made. He had a meerschaum pipe that was a glorious color. It was like old ivory. I always liked old books and old engravings, so I put the pipe with some of my old books and painted them."[2] In other words, despite the overtly masculine subject matter, Hirst domesticated it. This subtle element of subversion is one of the unusual aspects of her work.

At the same time, Hirst's technical virtuosity should not be ignored. Here, she creates a palpable tactility, modeled in a neutral palette and cloaked in a vignette-like effect that produces a dark, shallow space. The diagonal, worn edges of the open volume's pages contribute to the composition's stilled movement,

while the overturned, spilling pipe bowl adds elements of chance and action. The open tobacco pouch, with charred and unlit matches strewn around it, reveals a partial view of its label: the brand is most likely from the P. Lorillard Company, one of the oldest and largest tobacco companies in the United States, which was founded in 1760 and dominated the market during Hirst's era.

Hirst's mastery of trompe l'oeil challenges us to question what and how we see. Eyeglasses became a frequent motif for trompe-l'oeil painters, as they are an everyday object invested with poetic duplicity, able to both clarify and distort the world through their lenses. Although the spectacles in *Still Life with Book and Pipe* underscore the precision with which most of the items are painted (and thus viewed), the text of the open-faced book is blurred and rendered indistinct, remaining as obscured as the artist's hidden identity as a woman. S.G.

NOTES

1. Martha M. Evans, *Claude Raguet Hirst: Transforming the American Still Life* (Columbus, OH: Columbus Museum of Art, 2004), 18.

2. "A Pipe That Brought Fame," *New York Times*, June 4, 1922.

18 *[see also page 25]*

JOHN WESLEY JARVIS

American, b. England, 1780–1840

Henry Clay, 1814

Oil on canvas, 30 × 25 in.

Born in England, John Wesley Jarvis settled in Philadelphia with his family when he was about five years old. He began his first art training there with a number of artists (including Edward Savage) but in 1801 moved to New York City, where his career as an engraver and miniaturist began. In the early 1810s, he established his reputation; he would soon become the preeminent portraitist in New York City.

New York City provided Jarvis numerous opportunities to paint both city-sponsored and privately commissioned portraits of political figures, including members of both the Republican and Federalist political parties. He completed nearly four hundred portraits in his lifetime, the majority of which were created in New York, though he occasionally traveled south to seek commissions. In both subject and composition, the portrait of the Southern statesman Henry Clay is comparable to a handful of other formal portraits Jarvis painted around the same time of New York politicians. The work secured him the unprecedented 1814 commission from the city of New York for six full-length portraits of naval heroes of the War of 1812.

———·———

Showing Clay with paper in hand, Jarvis signals his subject's authoritative role, a prominent young political figure with an already admirable reputation and recognized oratorical skills. Jarvis shows Clay as a refined, well-dressed gentleman. Clay's brilliant

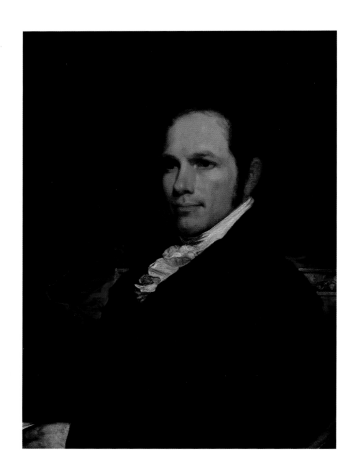

white shirt stands out in contrast against his black coat, and its scalloped-edge ruffles catch the light. Deep red drapery fills the space behind him, and the silhouette of a backlit column with a curvilinear base complements the outline of Clay's body. Seated in a red upholstered armchair of carved, gilt wood, Clay gazes self-assuredly into the distance. The warm tones of the backdrop and chair echo the tones of his complexion.

Henry Clay was born on April 12, 1777, in Hanover County, Virginia. His paternal ancestors came from England two hundred years before this work was created. Possibly the earliest portrait of Clay, at age thirty-seven, it depicts the Kentucky politician who three years earlier had become the youngest Speaker of the House to date. The portrait was painted while Clay was still serving in the House and just before he traveled to Europe to negotiate the Treaty of Ghent, which would bring an end to the War of 1812. Clay led the House in supporting President James Madison's call for war against Britain, and he felt it his duty to join the commissioners negotiating the peace treaty. Since Jarvis was based in New York, Clay likely sat for the portrait during his brief visit to the city, where he stopped for a few weeks before departing for Europe on February 25, 1814.[1]

The Clay portrait was reproduced for the first time in *McClure's Magazine* in 1897, the article noting that the painting was commissioned specifically for Mrs. Clay but that "she was so dissatisfied with it that she gave it to her niece."[2] Though the article's author, Charles Henry Hart, stated, "While it is not hard to understand Mrs. Clay's dissatisfaction with it as a likeness," he also called the work "an admirable piece of painting."[3] The painting is a flattering representation of Henry Clay, who would later be less romantically depicted by several other notable artists, resulting in at least seven portraits of him, including one painted by Jarvis's son, Charles Wesley Jarvis, in the year just prior to Clay's death.[4] L.S.

PROVENANCE: Estate of the artist; Niece of Mrs. Lucretia (née Hart) Clay, until 1878; Robert T. Ford, acquired from above?; Percy Rockefeller Estate.

LITERATURE: Harold E. Dickson, *John Wesley Jarvis: American Painter, 1780–1840, with a Checklist of His Works* (New York: The New York Historical Society, 1949), illus. 53; Charles Henry Hart, "Life Portraits of Henry Clay," *McClure's Magazine* 9 (May–October 1897): 939–941.

NOTES

1. Harold E. Dickson, *John Wesley Jarvis: American Painter, 1780–1840, with a Checklist of His Works* (New York: The New York Historical Society, 1949), 161.

2. Charles Henry Hart, "Life Portraits of Henry Clay," *McClure's Magazine* 9 (May–October 1897): 941.

3. Ibid., 939–941.

4. Other portraitists included Charles Bird King, Charles and Rembrandt Peale, George Caleb Bingham, and George Peter Alexander Healy.

19 *[see also page 48]*

EASTMAN JOHNSON

American, 1824–1906

At the Maple Sugar Camp, circa 1860s

Oil on canvas, 12½ × 15½ in.

Born the son of government official Philip C. Johnson in Lovell, Maine, Eastman Johnson is best known as a genre and portrait painter. Largely untrained in academic methods, he moved from New England to Washington, D.C., in 1844, or shortly thereafter, to begin his career as a portrait painter. Possibly through his father's political connections, he was permitted to set up a studio in one of the Senate committee rooms, creating portraits of prestigious government officials, including John Quincy Adams and Daniel Webster.[1]

In 1849, Johnson traveled to Europe to further his artistic training. Particularly interested in genre painting, he began his studies in Düsseldorf, where he worked under the guidance of Emanuel Leutze, and then continued, in 1851, to learn from contemporary Dutch artists at The Hague. He returned to the United States after his mother's death and in 1858 established a studio in the University Building at Washington Square Park in New York City, quickly gaining acclaim as one of the leading genre painters in America.

In the mid-1860s, Johnson began traveling to Fryeburg, Maine, to visit the maple sugar camps for their annual sugaring-off parties, producing roughly twenty-five oil sketches over ten years. These sketches document the entire sugaring-off process, though Johnson never completed a large studio painting of this subject.[2] Each lively gathering served as a time

not only to produce maple sugar (through a process of boiling the tree sap collected by members of the community) but also to mark the end of winter and the coming of spring.

Collected by Native Americans prior to the arrival of European colonists, maple sugar was uniquely American. This historical dimension of the maple-sugaring process, coupled with its freedom from associations of slavery (unlike the production of cane sugar in the American South and the Caribbean, which

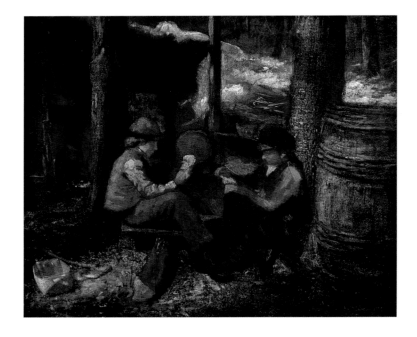

utilized slave labor), allowed maple sugar to become known as the "morally just" form of sweetener within antebellum America.[3] Largely a New England practice, sugaring off allowed Johnson to celebrate his identity as a native New Englander, as well as an American.

Art historians differ as to why Johnson never produced a large-scale painting that synthesized his studies. According to Brian T. Allen, the moral associations of the imagery may have proved to be too veiled for Johnson to find a patron for a larger work.[4] Patricia Hills suggests, however, that moralizing, large-scale paintings were falling out of favor; instead, art was increasingly judged on aesthetics alone: "art for art's sake."[5]

Created during the 1860s, *At the Maple Sugar Camp* shows Johnson transitioning away from the smooth, even application of paint of his early work, often with very precise details, toward a more dynamic handling of the medium. The canvas reveals a varied range of paint application, best seen when comparing the boy's arm on the right side of the painting with the tree behind and wood chips below. While the arm is lightly painted with loose brushstrokes, the wood has been thickly built up to create a textured surface. This experimental application of paint would lead to the more painterly, expressive brushwork that came to characterize Johnson's later works. S.B.

PROVENANCE: Sold at Sotheby's in 2002, lot number 155; Sold by Questroyal Fine Art, LLC, in 2009.

EXHIBITIONS: Sterling and Francine Clark Art Institute, Williamstown, Massachusetts, *Sugaring Off: The Maple Sugar Paintings of Eastman Johnson*, January 18–April 18, 2004, and traveling to The Huntington Library, Art Collections, and Botanical Gardens, San Marino, California, May 11–August 1, 2004.

LITERATURE: Brian T. Allen, "Eastman Johnson's Maple Sugar Paintings," *American Art Review* 16 (March–April 2004): 164–169; Brian T. Allen, *Sugaring Off: The Maple Sugar Paintings of Eastman Johnson* (New Haven: Yale University Press, 2004); Teresa A. Carborne and Patricia Hills, eds., *Eastman Johnson Painting America* (New York: Brooklyn Museum of Art, 1999).

NOTES

1. Patricia Hills, *Eastman Johnson* (New York: Clarkson N. Potter in association with the Whitney Museum of American Art, 1972), 6.

2. For a detailed discussion of these paintings, see Brian T. Allen, *Sugaring Off: The Maple Sugar Paintings of Eastman Johnson* (New Haven: Yale University Press, 2004); and Brian T. Allen, "Eastman Johnson's Maple Sugar Paintings," *American Art Review* 16 (March–April 2004): 164–169.

3. Allen, *Sugaring Off*, 38–40.

4. Ibid., 47.

5. Patricia Hills, "Painting Race," in *Eastman Johnson Painting America*, ed. Teresa A. Carborne and Patricia Hills (New York: Brooklyn Museum of Art, 1999), 159.

20 *[see also page 18]*

JOHN FREDERICK KENSETT

American, 1816–1872

School's Out, 1850

Oil on canvas, 18 × 30 in.

Signed and dated "FK 1850" at lower right

John Frederick Kensett was a second-generation Hudson River School artist. Born in Chesire, Connecticut, Kensett initially trained as an engraver under the direction of his father, Thomas Kensett. In the 1830s, he worked as a printmaker in New Haven and New York, during which time he developed his skills as a superb draftsman. By 1840, however, Kensett felt uninspired by engraving and began to paint.

Along with his contemporaries Asher B. Durand, John Casilear, and Thomas Rossiter, Kensett traveled in 1840 to Europe, where he studied old masters, drew from the antique and from life, and painted land-scapes for seven years. He spent some time in Paris but based himself primarily in England, with a sojourn in Italy from 1845 to 1847. During his European travels, Kensett made friends with many American artists. Both these connections and the landscapes he sent to New York from England established his reputation in the United States.

Back in America, Kensett was recognized for his talent. He settled in New York and later shared a studio with Louis Lang, which served as a social hub for artists. Kensett joined the Century Association and, by 1849, was elected as a full academician of the National Academy of Design. Frequent participation in exhibitions at the National Academy of Design and the American Art-Union, in addition to the approximately six hundred unsold pictures that were in his studio at the time of his death, attest to Kensett's prolific output. He was a founder of the Artists' Fund Society and the Metropolitan Museum of Art, which gave him a retrospective after his death, one of only a few exhibitions of a contemporary artist held at the museum in its early years.

———

Having recently returned from Europe, Kensett in *School's Out* balances traditional European landscape models with American motifs. The road that wanders diagonally from foreground to middle ground on the left is balanced against the sharper diagonal of the river; the high ground and large tree on the left are balanced against the low bank and fields on the right. Both are landscape structures derived from seventeenth-century Claudian landscapes. The natu-ralistic landscape also owes something to the work of Kensett's French contemporaries, the Barbizon paint-ers. The motif of the wooden country schoolhouse and the children playing outside it, however, is purely American.

In the words of a song published the same year as Kensett's painting in Albany, New York: "The day is past, school's out at last, / And homeward we'll return. / We gladly feel that we with zeal / Have taken hold to learn." Despite the lightheartedness, the second verse of the song, like the painting, has a moral to impart: "We feel as gay as those that play / And spend their hours in vain / At school each day, nor care if they /

Much knowledge do retain."[1] Kensett uses the setting to create a nostalgic scene of childhood in harmony with nature, as suggested by the words of another song, "Where the silver brook went dancing, Among the green trees shade . . . Stood the dear remembered schoolhouse."[2] Like the landscape, the subject of schooling children had national significance: "What safety is there for a free State but (under God) the free school? What more efficient antidote to the demagogue but the pedagogue? Who can look back, who can look around him over our own land, and say that politics constitute anywise more momentous a subject than the early education of the citizen?"[3] L.S.

NOTES

1. Solomon Cone, "Evening Song," *The Harmonia: New Collection of Easy Songs* . . . (Albany, NY: Erastus H. Pease & Co., 1850), 16.

2. Ibid., "The Old School House," 14.

3. Henry Barnard, "Report and Documents relating to the Public Schools of Rhode Island for 1848" (Providence, RI, 1849), 151.

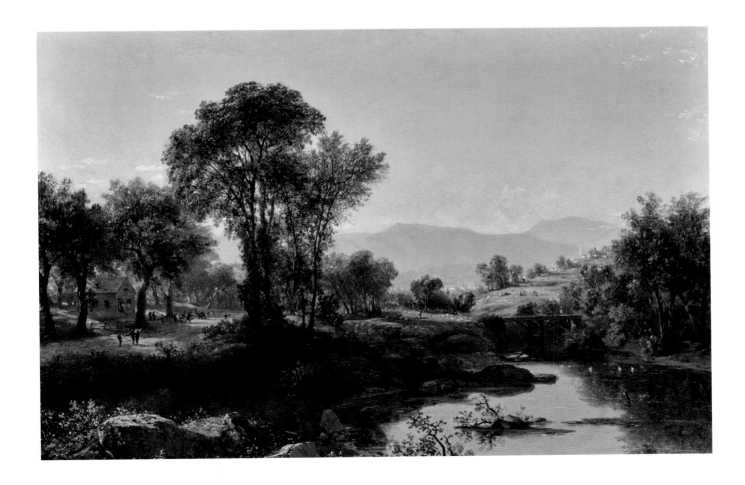

21

JERVIS McENTEE

American, 1828–1891

Sitting by the Fire, 1865

Oil on canvas, 15 × 12 in.

Signed and dated "J.M^c.E. 1865" at lower right

Little is known about Jervis McEntee's early life other than that he was born in Rondout, New York. He was friendly with Hudson River School artists, particularly Frederic Edwin Church, with whom he apprenticed in 1850–1851, as well as Church's friend Sanford Robinson Gifford. After a relatively unsuccessful stint as a businessman, McEntee pursued a career as an artist. In 1859, he moved into New York's famed Tenth Street Studio Building, constructed only two years prior. This modern facility—designed by Richard Morris Hunt and built by James Boorman Johnston—became home to many artists, who were attracted to the expansive work spaces filled with natural light and the opportunity to show their work and host receptions in a two-story exhibition hall. Working alongside other painters of the Hudson River School, such as Albert Bierstadt, John Frederick Kensett, and Thomas Worthington Whittredge, McEntee drew inspiration from his fellow artists. He became best known for his melancholic and poetic landscapes. He felt that "Nature is not sad to me but quiet, pensive, restful."[1] McEntee extended those qualities to the genre scene *Sitting by the Fire*.

———•———

A woman somberly dressed in black sits in quiet contemplation within a sumptuous setting, perhaps McEntee's studio at the Tenth Street Studio Building. The interior is decorated with both art and bric-a-

brac. An oval landscape hangs above the fireplace; the autumnal scene, marked by a sunlit mountain and floating clouds in the sky above, is evocative of McEntee's own landscapes, perhaps a gesture toward the work for which he is better known. Branches of fall foliage rest below the gilt frame. The mantelpiece is topped by a mirror, and four framed pictures hang on either side of it; the one on the lower right depicts a portrait bust of a soldier.

At the center of the mantelpiece is a chamberstick set down next to a floral arrangement. Porcelain vases and decorative objects line the mantel. On either end, candlesticks hold blue candles. In the mirror, the candle at left seems to be lit, while the candle at right, next to the portrait, is not. The portrait hangs above an empty Gothic Revival chair, both it and the unlit candle suggesting loss. The woman, presumably a Civil War widow, sinks into her own low chair, across from the dying fire. Gazing into the fireplace in meditation, she is absorbed in her thoughts. Painted in the last year of the war, the composition is an unusual view into a home. This woman may be safe and far removed from the war, but she is certainly not immune to its devastations.

McEntee himself served in the war as first lieutenant and then captain in the 20th Infantry Regiment of the New York State Militia. He returned to New York after three months on the Union front in

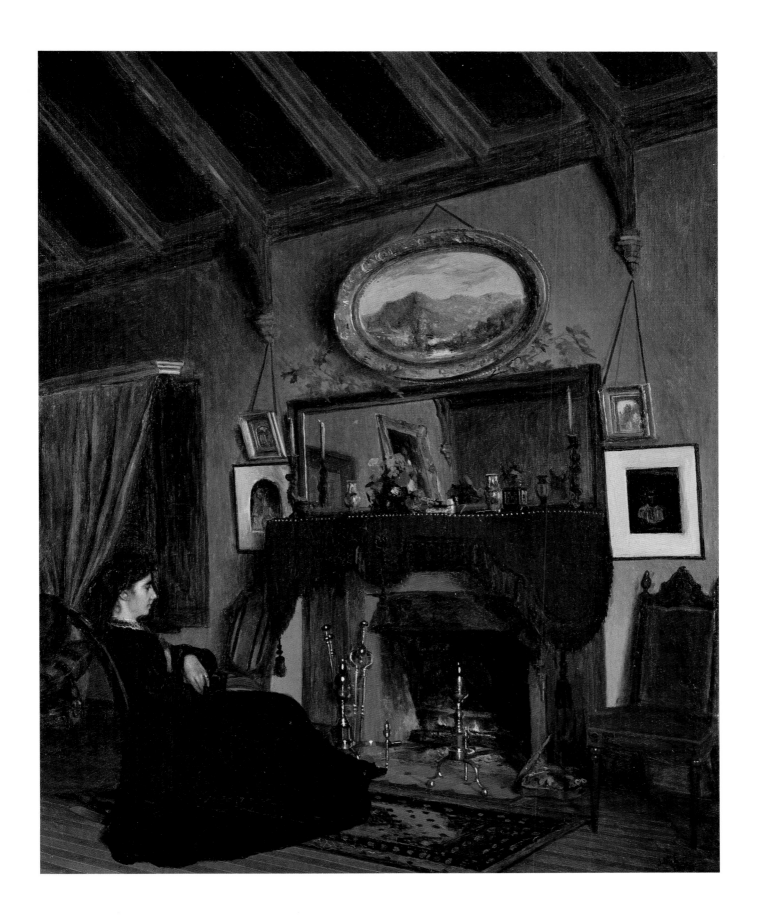

1861.[2] Whether in works like this or in his metaphorical landscapes, he ably captured the nation's despair. Isolated and contemplative, the painting captures the state of the nation at an uncertain time. L.S.

PROVENANCE: Wunderly Brothers Gallery (Pittsburgh, Pennsylvania); Private collection (Pennsylvania); Questroyal Fine Art, LLC (New York, New York), acquired from above, circa 2007.

LITERATURE: Kevin Sharp, *Bold, Cautious, True: Walt Whitman and American Art of the Civil War Era* (Memphis: The Dixon Gallery and Gardens, 2009), 125, plate 38, cat. no. 35; Mary Catherine Wood, "Jervis McEntee (1828–1891), *Sitting by the Fire*, 1865," in *Important American Paintings*, 3 (New York: Questroyal Fine Art, LLC, 2007), plate 41.

NOTES

1. George William Sheldon, *American Painters: With Eighty-three Examples of Their Work Engraved on Wood* (New York: D. Appleton and Co., 1879), 53.

2. [Sanford Robinson Gifford], "Military Correspondence, Washington, May 17, 1861," *The Crayon* 8 (June 1861): 135. See also "Art Items," *New-York Daily Times*, June 16, 1861; referenced in Eleanor Jones Harvey, *The Civil War and American Art* (Washington, D.C., and New Haven, CT: Smithsonian American Art Museum in association with Yale University Press, 2012), 249.

ENOCH WOOD PERRY, JR.
American, 1831–1915
Ice Skating Party, circa 1870
Oil on canvas, 20 × 15 in.

Enoch Wood Perry was born in Boston but moved with his family to New Orleans between 1843 and 1845. In 1852, he enrolled in the Düsseldorf Academy, working with Emanuel Leutze for nearly three years. He then went to Paris to study with Thomas Couture. From 1856 to 1858, he served as the American consul in Venice. He returned to America in 1858, settling in Philadelphia, and soon exhibited at the National Academy of Design, the Boston Athenaeum, and the Pennsylvania Academy of the Fine Arts.

In 1860, Perry opened a studio in New Orleans, specializing in portraiture; he painted portraits of Senator John Slidell and Jefferson Davis the following year. In 1862, he traveled to San Francisco, painting in Yosemite and befriending Albert Bierstadt. He went to Honolulu in 1864 and Salt Lake City in 1865; while in Salt Lake City, he painted a portrait of Brigham Young to hang in the City Council chambers. He also established a short-lived Desert Art Union before settling in New York in 1867. Working out of Bierstadt's former studio in the Tenth Street Studio Building, Perry became an active member of the art scene. From 1878, Perry was again living in San Francisco and was patronized by railroad moguls Collis P. Huntington and Leland Stanford, but by 1882 he had returned to New York. At age sixty-eight, he married the writer Fanny Field Hering; the couple spent summers together at his New Hampshire studio and winters traveling abroad or working in New York. Perry died in New York in 1915 at age eighty-four.

Though a skillful and successful portraitist throughout his career, Perry is best known for his genre paintings. The same was true in his own time, the New York *Art Journal* reporting in July 1875 that Perry occupied a position "very nearly at the head of our genre painters."[1] Like numerous other nineteenth-century American painters, Perry preferred compositions of a familiar and sincere American character. The losses and upheaval of the Civil War prompted many artists to turn inward and depict the simple pleasures of ordinary life.

Perry's genre paintings typically portray quiet rural moments and everyday subjects, especially leisure activities, combining his training in European art with the influence of American genre painters of the previous generation, such as William Sidney Mount. Ice-skating was a favorite subject of seventeenth-century Dutch genre painters, but the subject is also distinctly American. Ice-skating was a favorite pastime among the growing American urban middle class, and the activity grew immensely popular during this period when ice skates could be mass produced and custom fit.[2] These ice skaters, however, seem to be not city dwellers but rural folk. The winter revelers enjoy the laughs and tumbles of ice-skating on a frozen canal or inland lake nestled between nearly bare overhanging trees. Frost clings delicately to the tips of the dark branches, creating a haunting pattern against the pallid sky and framing a late-afternoon sun. A centrally placed figure in a bright-red coat draws the

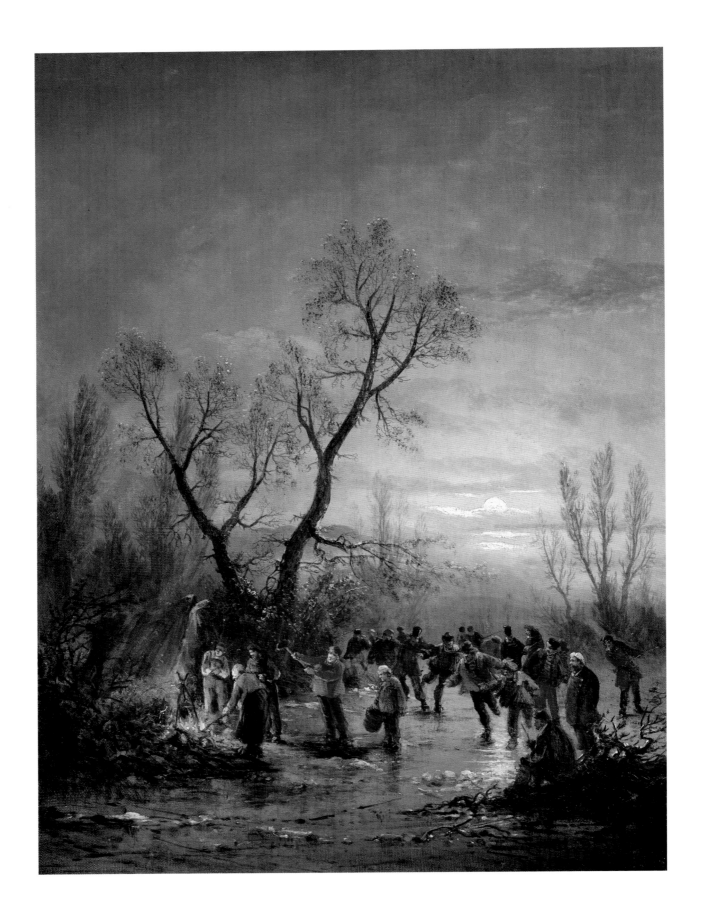

Klaes Molenaer (Dutch, 1630–1676), *Winter Scene with Skaters*, n.d.
Oil on panel, 23½ × 32 in. *Crocker Art Museum, E. B. Crocker Collection, 1872.629.*

eye into the gathering with an expressive gesture. With arms and legs thrown akimbo to keep balance, the figures display a carefree joy. A few participants huddle around a fire to keep the chill at bay. Perry's masterful manipulation of light makes the fire's glow welcoming even to outside viewers safe from the cold. S.G.

PROVENANCE: Questroyal Fine Art, LLC (New York, New York), 2010.

NOTES

1. "American Painters—E. Wood Perry," *The Art Journal* 1 (1875): 216.

2. See, for example, Winslow Homer's many images of skating parties from 1859 into the early 1870s. Indeed, the lake in Central Park was originally designated a skating pond in the 1858 plan by Olmsted and Vaux.

23 *[see also page 37]*

WILLIAM TROST RICHARDS

American, 1833–1905

Delaware River Valley, 1864

Oil on canvas, 18 × 24 in.

Signed and dated "W^m T. Richards 1864" at lower left

A prominent landscape and marine painter, William Trost Richards enjoyed a long and prolific career as one of America's leading artists in oil and watercolor. Born in Philadelphia, he studied painting privately and at the Pennsylvania Academy of the Fine Arts in the 1850s, as well as during his travels to Europe in 1855 and 1856. In 1856, he read John Ruskin's *Modern Painters*, which—along with seeing the work of British artists, including Pre-Raphaelites, in Philadelphia at the 1857 traveling Exhibition of British Art—prompted his participation in the reform of American landscape painting and the elevation of watercolor as a fine art.

In 1863, Richards was elected an academician of the Pennsylvania Academy of the Fine Arts. He was also invited unanimously to be a charter member of the Association for the Advancement of Truth in Art, a group of artists that became identified with the short-lived American Pre-Raphaelite movement (about 1857–1870), which encouraged an almost scientific approach to depicting nature and answered Ruskin's call for truth to nature. Throughout his career, Richards captured picturesque views of the woodlands and coasts of New England with a precision akin to technical investigation.

Ruskin's endorsement of Joseph Mallord William Turner's watercolors was also a factor in the intense interest American painters began to take in watercolor, resulting in the formation of the American Society of Painters in Water Colors in 1866. Richards was a founding member and became widely known as one of the movement's more prolific and successful talents.

———·———

Painted during the American Civil War, *Delaware River Valley* shows little sign of the turbulence of the moment. Instead, Richards invites viewers to focus on the appeal of an iconic American landscape, showcasing the very river that General George Washington once triumphantly crossed during the fight for America's independence. Executed a year after Richards joined the American Pre-Raphaelite artists' Association for the Advancement of Truth in Art, the woodland scene depicts the Delaware River downstream from the Catskills and Adirondacks, where artists of the previous generation had developed an American landscape painting tradition. Richards's sylvan landscape departs stylistically from scenes by artists of the Hudson River School in its almost scientific fidelity to nature, being true to his group's precept that an exact likeness was superior to an artist's interpretation or synthesis of idealized views of nature.

As followers of Ruskin, Richards and his colleagues in the Association for the Advancement of Truth in Art pursued painting using a broad spectrum of bright colors, a polished finish, and

exacting detail to create a different sort of landscape tradition—"in such a way that the poet, the naturalist and the geologist might have taken large pleasure from it."[1] Adherence to this principle is evident in the work's precise particulars, such as the individual blades of grass articulated in the foreground and the rocks beneath the surface of the water visible in the shallows of the riverbed. Richards's painting follows Ruskin's advice in *Modern Painters*—and that of his American followers—who claimed the use of a full range of color was key to depicting nature truthfully.

Whereas the technical aspects of the work break with American idealism, the subject matter nevertheless perpetuated a history of American bucolic scenes. Though Richards's composition offers a new style, both the composition and the subject are similar to the pastoral scenes painted by the generation before. The painting's title, however, underscores the fact that Richards is offering a specific place for our contemplation, the Delaware River Valley, rather than a generic scene. Richards helped to define the American Pre-Raphaelite movement with paintings such as this, which, as one contemporary critic wrote in 1867, were "so carefully finished . . . [that] the leaves, grasses, grain-stalks, weeds, stones, and flowers . . . seem not to be . . . a distant prospect, but lying on the ground, with the herbage and blossoms directly under our eyes."[2]

M.O.

PROVENANCE: Kenneth Lux Gallery (New York, New York), "New Acquisitions in American Paintings," 1983.

NOTES

1. "Notices of Recent Pictures," *The New Path* 1 (1864): 162.

2. Henry Theodore Tuckerman, *Book of the Artists: American Artist Life, Comprising Biographical and Critical Sketches of American Artists: Preceded by an Historical Account of the Rise and Progress of Art in America* (New York and London: G. P. Putnam & Sons, 1867), 524.

24

WILLIAM TROST RICHARDS

American, 1833–1905

Sundown, Atlantic City, 1874

Watercolor, 11 × 17⅝ in.

Signed "Wᵐ T. Richards 74" at lower left

In the 1870s, Richards began a series of paintings depicting New Jersey's Atlantic City, one of the first seaside amusement parks in the United States, which was built to accommodate hundreds of visitors seeking an escape from the summer heat. Writing to his patron George Whitney, Richards declared, "I and my umbrella, and weather-beaten nose go up and down the shore."[1] In 1873, Richards submitted an oil painting of Atlantic City to the annual juried exhibition of the Paris Salon, though he depicted it not as a tourist destination but as a deserted shore. The following year, he painted this delicate watercolor, *Sundown, Atlantic City*.

Expertly layering opaque color on transparent washes to achieve a strong sense of realism, Richards captures the Atlantic Ocean as it gently laps at the white sand beaches and grassy wetlands. The view is both accurate and idealized. Like the pastoral scenes of earlier generations, Richards's seascapes belie the reality of Atlantic City as a place thronged with tourists. Boats floating out to sea on the left, birds flying free overhead, and the tranquil, deserted shore all look back to a time of untrammeled beauty, when nature and humanity were in harmony.

As critics noted, Richards's landscapes had the clarity and stillness of still-life painting, which a critic

for the magazine *The Aldine* described in 1874 as the artist's "literalness," noting his talent for "sculpturing the waves with the precision of a cameo-carving, and capturing a solid blaze of light without any trick of shadow."[2] The sky, achieved with soft washes of transparent pink, blue, and lavender, suggests the end of a foggy day, as gray mist and white clouds fade into pastel hues. Executed in more opaque color, and reflected on the surface of the waves on the left and the turquoise marshes on the right, is Richard's fine, changing light, the cooler tones of creeping shadow in the waves and marshes distinct from the last gleams of the sun. Placing his viewers at the edge of this scene, Richards invites them to imagine the sound of ebbing and flowing waves, the call of seabirds, and the smell of the ocean spray. The scene seems to beckon viewers to have their own solitary moments with nature— and to experience a direct, exclusive connection to the earth. M.O.

NOTES

1. William Trost Richards to George Whitney, Gloucester, July 2, 1872, William Trost Richards Papers, 1848–1920, Archives of American Art, Smithsonian Institution, Washington, D.C.

2. "Marine Painters of America," *The Aldine* 7 (July 1874): 137.

25 *[see also page 42]*

SEVERIN ROESEN

American, b. Germany, 1816–1872?

Still Life with Fruit and Wine, 1862

Oil on canvas, 24 × 30 in.

Severin Roesen was born near Düsseldorf in the town of Boppard-am-Rhein, Germany. He worked first as a porcelain painter in Cologne, where he exhibited a floral still life in 1847. That year he married Sophia Jacobina, and they immigrated to New York in 1848. Sophia died the following year, whereupon he married Wilhelmine Ludwig, with whom he had two children. During his time in New York, Roesen exhibited eleven paintings at the American Art-Union between 1848 and 1852. For reasons that remain unclear, he left his family behind in New York and relocated to Pennsylvania in 1857, first taking up residence in Philadelphia and then living in rural, German-American communities in Harrisburg and Huntingdon; he settled permanently in the affluent community of Williamsport around 1863. Producing hundreds of still lifes, only a few dozen of which are signed, Roesen exhibited works at the Maryland Historical Society in Baltimore in 1858, at the Pennsylvania Academy of the Fine Arts in 1863, and at the Brooklyn Art Association in 1873. The place and time of his death are unknown, but his last painting is dated 1872, and his name ceased to appear in the Williamsport directory after that year.[1]

The fruits Roesen paints are not confined to the season in which they are abundant, a typical feature of European still-life paintings. In the tightly packed, multi-tiered cornucopia of several harvests' worth of fruit, there is a tension between the crisp, firm dimensionality of the bountiful baskets of fruit and the delicate shimmer of the ripe surfaces. Such paintings, as analysis of Roesen's underdrawing through x-rays has revealed, are expertly and meticulously designed; but at the same time, they present an illusion of almost casual freshness.[2]

This harvest is displayed on a narrow, double-tiered shelf; fruit dangling over the edges creates an illusion of immediacy. The abundance complements the appetites of viewers who would enjoy the painting while dining at home. An image of Victorian excess, Roesen's over-brimming assortment of sweet delights evidences a nation growing in prosperity, thanks to increasingly industrialized cultivation and the widely accessible transportation of goods. S.G.

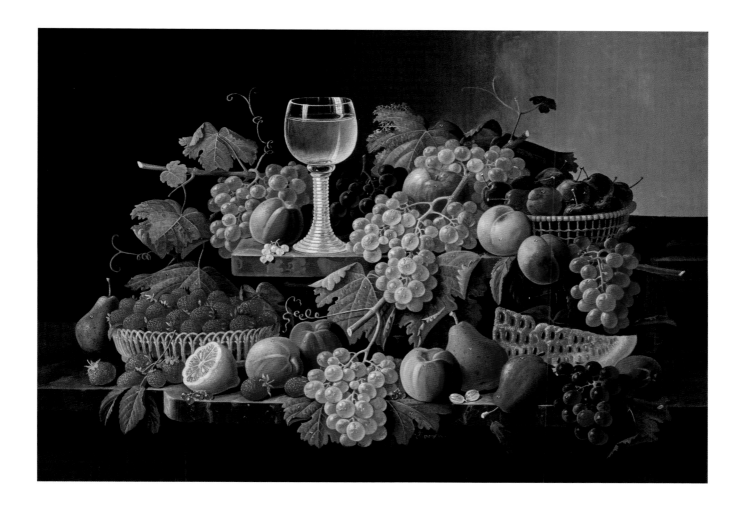

NOTES

1. Biographical information is found in Richard B. Stone, "Not Quite Forgotten: A Study of the Williamsport Painter, S. Roesen," *Lycoming Historical Society Proceedings and Papers* 9 (November 1951): 3–40, with a catalogue of known paintings and bibliography; Maurice A. Mook, "Severin Roesen: The Williamsport Painter," *Lycoming College Magazine* 25 (June 1972): 33–41; Maurice A. Mook, "Severin Roesen: Also the Huntingdon Painter," *Lycoming College Magazine* 26 (June 1973): 13–16, 23–30; Lois Goldreich Marcus, *Severin Roesen: A Chronology* (Williamsport, PA: Lycoming County Historical Society and Museum, [circa 1976]), with bibliography; Judith H. O'Toole, "Search of 1860 Census Reveals Biographical Information on Severin Roesen," *American Art Journal* 16 (Spring 1984): 90–91.

2. Mark DeSaussure Mitchell, Bill Brown, Katie A. Pfohl, Carol Troyen, and Philadelphia Museum of Art, *The Art of American Still Life: Audubon to Warhol* (New Haven: Philadelphia Museum of Art in association with Yale University Press, 2015), 156.

26 *[see also page xii]*

RUSSELL SMITH

American, b. Scotland, 1812–1896

Silver Lake with Indian Teepee, 1867

Oil on canvas, 12 × 18 in.

Signed "R.S." at lower center

William Thompson Russell Smith was born in Glasgow, Scotland, the son of a silversmith who also worked in steel and a mother who studied medicine and later worked as a midwife in the United States. The family immigrated and settled in Pittsburgh, Pennsylvania, where Smith was trained by local artist James R. Lambdin. He established a career that included working as an illustrator for scientific publications (such as geological surveys) and books, as well as painting panoramas and theater sets and curtains. In addition, Smith painted small landscapes, in oil and watercolor.

In 1839, Smith married Mary Priscilla Wilson, a flower painter and teacher of French. The couple raised two more Philadelphia artists—Mary Smith, a painter of animals, and Xanthus Smith, a prolific landscape painter and influential art instructor at Princeton University. Throughout his long and successful career, Russell Smith exhibited widely and worked for leading theaters and museums in New York, Boston, Philadelphia, and San Francisco. He also supported women artists: after his daughter Mary's untimely death, he founded The Mary Smith Prize, a rare acknowledgment of female talent awarded annually to a native Philadelphia woman painter from 1879 to 1968. While he never actually visited California, California-related commissions included a panorama of the Isthmus of Panama—one of the primary ways of getting to California during the gold

rush—as well as a panorama of California in 1848 that included images of Sutter's Fort and Sutter's Mill, commissioned for the opening of P. T. Barnum's Museum in Philadelphia in 1849. Smith's panorama of New York Harbor was featured in San Francisco in 1853 in Junius Brutus Booth's "The Grand Panoramic Play of New York and San Francisco."[1]

This fanciful scene takes place at Silver Lake, a part of the Finger Lakes region of western New York State, which was once the home of the Seneca, who were part of the Iroquois League. Silver Lake was also a place of local legend, most notably the "Silver Lake Serpent," which perhaps intrigued the native-born Scot: according to local Native American traditions and sensational newspaper accounts, the lake's wildlife included a monster, incidents of which were reported in 1855 and in the 1880s.[2]

Smith likely completed the intimately scaled *Silver Lake with Indian Teepee* at Edge Hill Castle, a crenellated manor house he designed and built in Jenkintown, Pennsylvania, in 1854. The home contained a two-story studio where Smith worked on large-scale theater curtains and panoramas as well as smaller canvases, including, that same year, *River Landscape*, another secluded view of Native Americans canoeing in and communing with nature.

Silver Lake with Indian Teepee speaks to Smith's interest in studying, representing, and preserving his personal vision of the ideal American landscape, as he wrote:

> The small landscapes were not painted for sale but because I felt in the mood for the particular subject taken up at the time; and they represent some arrangement of color, of light and shade or tone which something I had recently seen in Nature suggested; they are therefore likely to be the best representations of my mind and character as a painter, and to be more original than subjects selected by and painted for another.[3]

About his style, Smith confessed to striving for a "general expression" rather than scientific detail and expressed fear of becoming "mechanical in evenness and smoothness of touch and surface." "I love nature more than I do workmanship," he explained, "although I know that the latter is the quality most admired by the multitude."[4] In other words, Smith purposefully avoided too much attention to detail, preferring theatrical staging and color achieved through quick brushwork. The placid water of Silver Lake, the gently tethered canoe, the waterfall, the cumulus clouds, the fading purple mountains in the distance, and the companionable gathering of Native Americans all communicate Smith's partiality for idealized nostalgia rather than adherence to what he might actually have seen. The artist also prevents viewers' easy trespass into his perfect, secluded scene. A fallen tree, brambles, and other natural debris prohibit entry into the composition, allowing only the teepee, the canoe, and the Native Americans to inhabit this virgin

wilderness. This is Smith's world, made possible by his own financial freedom, and yet it is one that found ready favor in juried exhibitions and on the competitive American landscape painting market. M.O.

PROVENANCE: Sotheby's Arcade Auctions: American Paintings, Drawings, and Sculpture, February 1, 1990.

NOTES

1. "Page 3 Advertisements," *Daily Alta California* (San Francisco), October 29, 1853.

2. "The Silver Lake Sea Serpent a Fixed Fact," *The Western Democrat* (Charlotte, NC), August 17, 1855.

3. Virginia Elnora Lewis, *Russell Smith, Romantic Realist* (Pittsburgh: University of Pittsburgh Press, 1957), 135.

4. Russell Smith, October 1890, Memorandum, Smith Family Papers, Archives of American Art, Smithsonian Institution, Washington, D.C.

27 *[see also page 50]*

THOMAS WORTHINGTON WHITTREDGE

American, 1820–1910

Barn Interior, circa 1852

Oil on canvas, 12 × 9 in.

Signed "W Whittredge" at lower left

Thomas Worthington Whittredge, born in Springfield, Ohio, began his artistic career as a house and sign painter. To make additional income, he created portraits. Not until 1843 did Whittredge take up landscape painting in earnest. Traveling to Düsseldorf, Germany, in 1849, he decided to pursue training as a landscape painter at the Düsseldorf Academy.

While studying abroad, Whittredge met Emanuel Leutze and even posed for his iconic large-scale *Washington Crossing the Delaware* (1851), which was created in Germany. Returning to the United States after nearly ten years in Europe, Whittredge began to work at the famous Tenth Street Studio Building in New York City. While his compositions were profoundly influenced by the European landscape tradition, Whittredge also drew upon the work of American landscape painter Thomas Cole, as he became interested in defining a national landscape through painting.[1] This negotiation of European landscape tradition with American imagery can be seen throughout Whittredge's work.

Barn Interior is closely related to a larger painting, *Interior of a Westphalian Cottage* (1852), one in a series of works Whittredge painted in the 1850s that explored the tension between interior and exterior space.[2] Henry David Thoreau, in the fourth chapter of *Walden*,

encourages his readers to expand their contemplation beyond books and academic learning and incorporate moments of peaceful reflection.[3] Sitting in front of his window, Thoreau remains quiet, taking in the chaos of the outside world while remaining emotionally and intellectually detached. For Thoreau, the window becomes a metaphor for his transcendental practices.

In *Barn Interior*, Whittredge includes an open window and door to create a space conducive to contemplation. He warms the composition by using a diffuse, golden light that floods the scene. Placing farm animals in the patches of light at the woman's feet, Whittredge concentrates the activity, directing viewers to reflect on the private, internal world of the knitting woman and to be drawn to the brightness of the open door through the gaze of the goats. In contrast, the larger painting is darker in atmosphere and tone, and the figure is alone and smaller in relation to the space.

Details throughout the composition underscore the course of time. Beginning with the yellowed, chipped glass of the window above to the slightly off-kilter doorway, Whittredge highlights the history of the space itself. Balancing careful, local details with a sense of tranquility, Whittredge emphasizes the nostalgia and longing that were central to the development of the open-window theme in Romantic painting. Suggesting an idyllic past just out of reach,

from an abandoned spinning wheel in the background to a man's hat tucked into the rungs of the ladder, the objects seem to be waiting in a state of transition. This sentiment also pervades the discarded cabbage leaves, which have been swept into a large pile on the floor, the broom still resting in the middle of the debris. Such elements create a tension between inward meditation and a larger contemplation of the world, encouraging viewers to reflect on the passage of time.

S.B.

PROVENANCE: Questroyal Fine Art, LLC (New York, New York), sold in 2011.

NOTES

1. Worthington Whittredge, *The Autobiography of Worthington Whittredge, 1820–1910*, ed. John I. H. Baur (Brooklyn, NY: The Brooklyn Museum, 1942), 41.

2. Oil on canvas, 27⅝ × 19⅞ in., Smithsonian American Art Museum, 1967.142.2. Westphalia is a German province, the border of which is only twenty-five miles from Düsseldorf.

3. Henry David Thoreau, *Walden* (1854). According to Anthony F. Janson's monographic study of the artist, Whittredge was aware of the associations of the open-window theme in Romantic literature and painting. Particularly popular in German Romanticism, the open window was used to express longing or unfulfilled desire, seen in works such as Caspar David Friedrich's *Woman at the Window* (1822) in which a young woman whose back is turned to the viewer gazes out through the opened window before her. See Anthony F. Janson, *Worthington Whittredge* (Cambridge: Cambridge University Press, 1989), 77.

THOMAS WORTHINGTON WHITTREDGE
American, 1820–1910

Ducks on a Pond, 1864

Oil on canvas, 15 × 24 in.

Signed "W Whittredge" at lower right

Following his return to the United States in August 1859 after an extended stay in Europe, Whittredge continued to draw upon both European and American sources in the development of his landscape paintings. In *Ducks on a Pond*, he engages in a dialogue with the French Barbizon tradition through his depiction of an ordinary, quiet scene containing a low horizon line and large, open sky, as well as with the Hudson River School through his vibrant depictions of the American landscape in the fall. According to Anthony F. Janson's biography of the artist, this painting was created the same year that Whittredge included his name as one of the backers of the American dealer Samuel P. Avery's acquisition and sale of a collection of French art.[1] While the Barbizon style did not achieve widespread popularity in the United States until the 1880s, primarily through the work of George Inness, Whittredge's desire to promote and incorporate elements of a French landscape style suggests that he was searching for a way to distinguish his work within the diverse field of American landscape painting. He persisted in following his European training and interests throughout his career, allowing him to create vibrant and personal images of the American terrain.

In *Ducks on a Pond*, Whittredge combines the rich colors of the autumnal landscape with a quiet scene of ducks gliding tranquilly on the water. Participating in the tradition of depicting the American landscape in the fall, popularized by earlier Hudson River School artists such as Jasper Francis Cropsey, Whittredge creates a mosaic of bright greens, golden yellows, bold reds, and deep browns within the dense foliage. Peppering the landscape with dashes of bright white from the rising birch trees to the floating ducks, he unifies and lightens the overall view, highlighting the crisp autumn day. Whittredge also employs a range of brushwork to make a diversely textured landscape. Bold, free application of paint in the floating clouds contrasts with fine, delicate strokes in the foreground trees. Using the movement of the ducks to draw viewers into the center of the painting, he juxtaposes the ducks' direction with the diagonal thrust of the birch tree that reaches up to the sky, creating a dynamic composition.

Painted during the height of the Civil War, Whittredge's calm landscape scene does not convey the tumultuous nature of the period, though the broken tree does suggest loss. According to Whittredge's autobiography, the war did not particularly impact his artistic production. "The Civil War had disturbed many things, but strange to say, it had less effect upon art than upon many things

with more stable foundations. . . . The painters sold their pictures readily and native art flourished more conspicuously than now."[2] In essence, the Civil War did not hinder art making; it provided an opportunity for artists such as Whittredge to produce an American form of expression. Within this context, *Ducks on a Pond* seems intended to resonate as a distinctly American scene. Depicting the American landscape in autumn—a season strongly associated with the American Northeast—Whittredge may have hoped to promote feelings of patriotism and unity during this time of national conflict. S.B.

PROVENANCE: Questroyal Fine Art, LLC (New York, New York).

LITERATURE: Anthony F. Janson, *Worthington Whittredge* (Cambridge: Cambridge University Press, 1989), 98, 100, lists whereabouts as unknown.

NOTES

1. Anthony F. Janson, *Worthingon Whittredge* (Cambridge: Cambridge University Press, 1989), 98. Janson suggests that *Duck Pond* is particularly influenced by the work of French painter Jules Dupré, combined with elements drawn from the second-generation Hudson River School painter Sanford Robinson Gifford.

2. Worthington Whittredge, *The Autobiography of Worthington Whittredge, 1820–1910*, ed. John I. H. Baur (Brooklyn, NY: The Brooklyn Museum, 1942), 43.

INDEX

FACING: William Trost Richards, *Sundown, Atlantic City*, 1874, detail (cat. no. 24).

American Beauty and Bounty

The Judith G. and Steaven K. Jones
Collection of Nineteenth-Century Painting

was published by the Crocker Art Museum

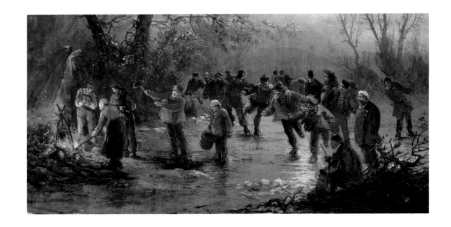

PRODUCED BY WILSTED & TAYLOR
PUBLISHING SERVICES

Project manager Christine Taylor

Production assistant LeRoy Wilsted

Copy editor Melody Lacina

Designer and compositor Nancy Koerner

Proofreader Nancy Evans

Indexer Mary Mortenson

Color manager Evan Winslow Smith

Printer's devil Lillian Marie Wilsted

Printer and binder R. R. Donnelley Asia